HEROES AND BEYOND

HOW TO DRAW THE LEADING AND SUPPORTING CHARACTERS OF TODAY'S COMICS

CHRISTOPHER HART

WATSON-GUPTILL PUBLICATIONS
NEW YORK

Copyright © 2009 Cartoon Craft, LLC

Design by Laura Palese

Contributing Artists:
Fabio Laguna
Darryl Banks
Luiz Lira
Francisco Oliveira de Amorim
Cesar Razek
Will Conrad
Kevin Sharpe

Published in the United States by Watson-Guptill Publications
an imprint of the Crown Publishing Group
a division of Random House, Inc., New York
www.crownpublishing.com
www.watsonguptill.com

WATSON-GUPTILL is a registered trademark and the WG and Horse
designs are trademarks of Random House, Inc.

Library of Congress Cataloging-in-Publication Data

Hart, Christopher.
Superheroes and beyond : how to draw the leading and supporting
characters of today's comics / Christopher Hart. -- 1st ed.
 p. cm.
Includes index.
ISBN 978-0-8230-3305-8 (pbk.)
1. Superheroes in art. 2. Comic strip characters. 3. Figure drawing--
Technique. I. Title. II. Title: How to draw the leading and supporting
characters of today's comics.
NC1764.8.H47H37 2009
741.5'352--dc22

 2009015175

ISBN 978-0-8230-3305-8
Printed in China
10 9 8 7 6 5 4 3 2 1
First Edition

CONTENTS

INTRODUCTION

Superheroes. They are, beyond question, the most popular characters in comics. Their eye-catching costumes, superpowers, and sculpted physiques capture the imaginations of readers of all ages. Now there's a book devoted to how to draw them. You can draw the way you've always wanted to. If you didn't have all the knowledge necessary to create great comic book characters, then this will give you the edge you need. This book is for beginners as well as more experienced artists. These carefully crafted, step-by-step tutorials will help you to crush the competition. That's because there are a huge number of illustrated examples in this book. You won't have to read your way into drawing, you'll see exactly how to do it.

But we'll also go beyond superheroes and learn how to draw the supporting characters essential to any good action adventure, including supervillains, news reporters, mutants, and more. There's a must-know chapter on drawing the sexy gals (the action heroines) of comics—because, as any comic book editor will tell you, beautiful girls are what sell comics. So you'll definitely want to use this chapter to sharpen your game.

You'll get the know-how about body dynamics and use it to draw convincing action poses. We'll also cover exaggeration, expressions, costumes, using light and shadow to create intensity, drawing the splash page, and layout and composition.

The power of the universe is in your hands.

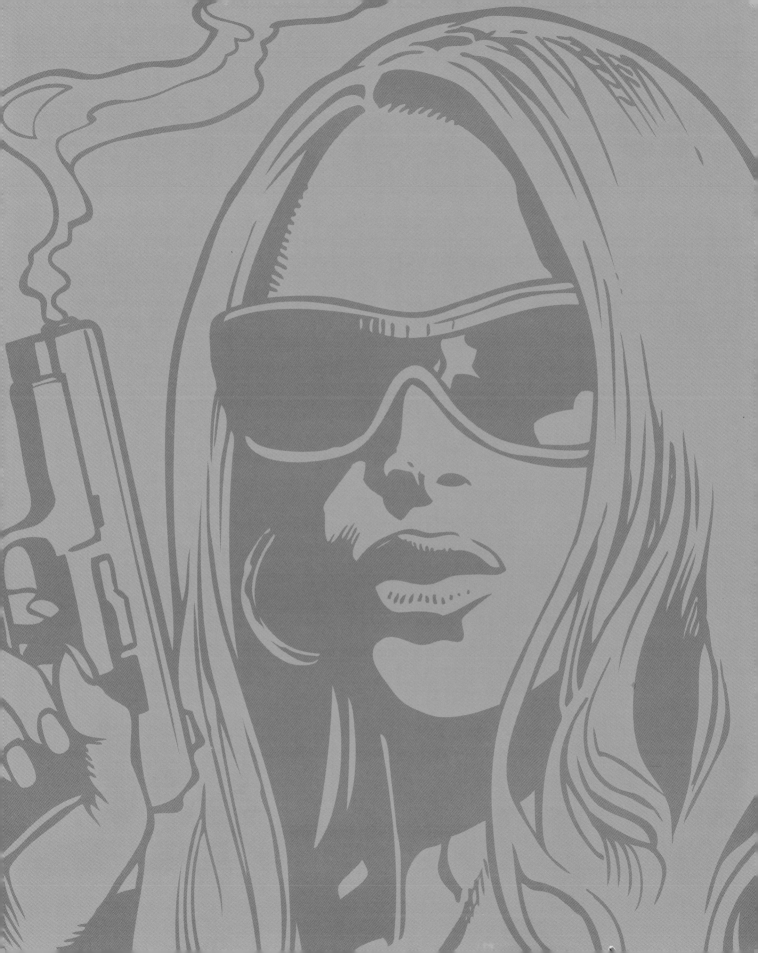

CHAPTER **1**

The
SUPERHERO
HEAD

Superheroes are like ordinary people who have been hit with the "more" wand. They're just like you and me, only *more*. More virile, more attractive (hard to imagine, but true), more rugged, and for women, more, well, more of everything.

Drawing superheroes is more than a matter of sticking a mask on a face or a cape on a body. You've got to have the right proportions to begin with, in order to create that look of intensity for which superheroes are famous. We'll begin with the head, work our way up to bodies, and then reveal the secrets that will enable you to draw these great characters in action poses . . . and beyond.

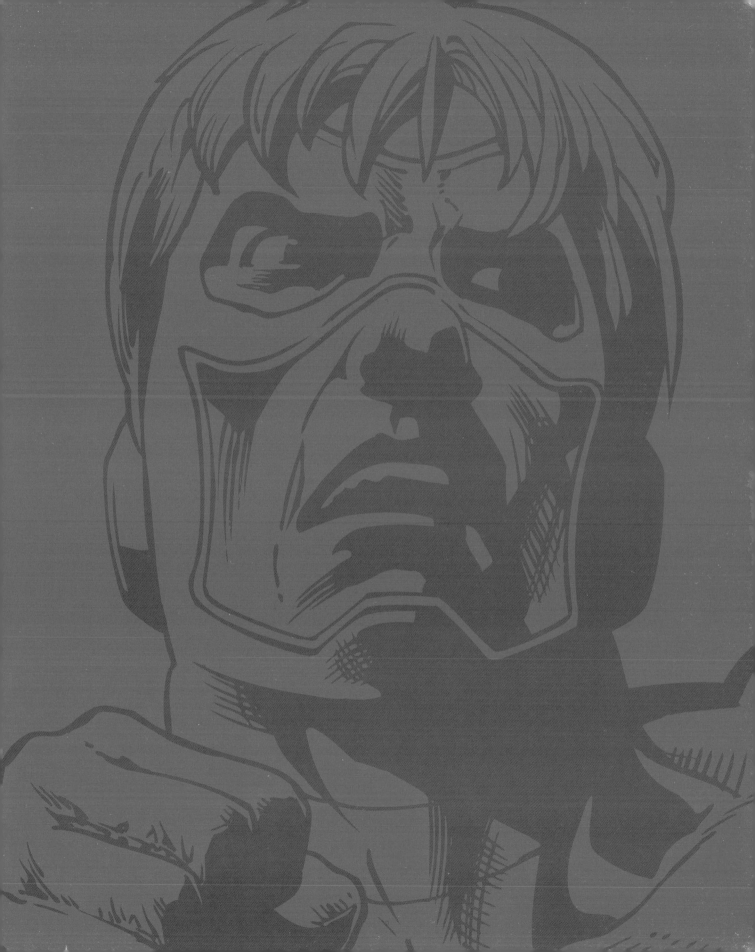

The head is not based on a circle, like the cartoon head, nor is it an egg shape, primarily because of the wide chin of the superhero. The male head is more of a boxy-looking oval. Give this foundation shape a good amount of width; you don't want to end up with a skinny head. Both male and female action heroes have conspicuous cheekbones, which widen out the face. On guys, it makes them look tough; on gals, it makes them look sexy.

In a realistic drawing, the eyes fall exactly halfway down the head. But for idealized comic characters, the eyes are place slightly higher. This serves to emphasize the heroic chin. Note, too, the narrowness of the eyes; this gives the character a severe look. Lastly, work in the vertical facial crease on each side of the mouth.

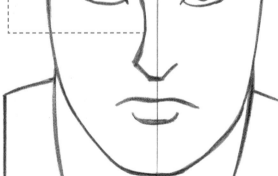

Narrow, very horizontal eyes.

Bridge of nose is slightly curved.

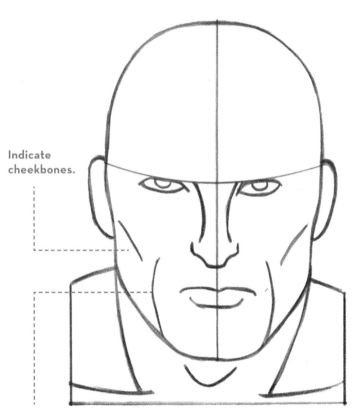

Indicate cheekbones.

Muscular crease on either side of mouth.

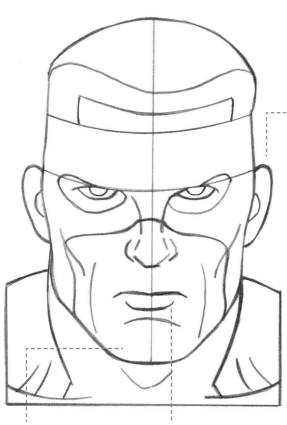

Eyes at level of eyebrows.

"Squared off" chin.

Heavy lower lip.

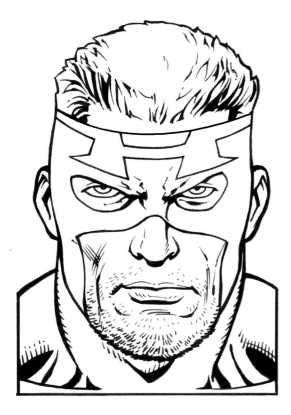

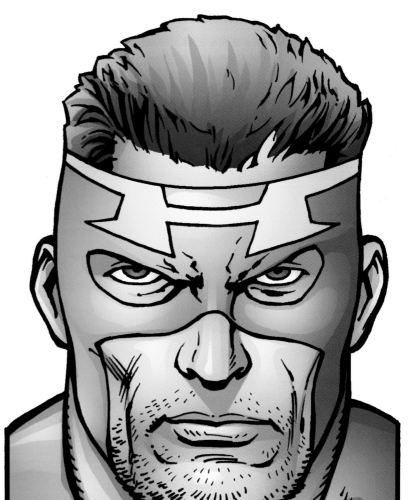

PROFILE

First, note the guidelines, which help with the placement of things. The vertical line is not directly in the middle of the head shape but a little closer to the back of the skull. The front of the ear attaches to that and falls basically between the two horizontal guidelines. The bottom of the ear and the bottom of the nose align at the same horizontal guideline. And the ear and jawbone occupy the same vertical guideline.

Note how in the side view, or profile, you can really see how massive the jaw is. The base of the jaw, just under the ear, is a actually a muscle known as the *masseter*. It gives him a masculine, rock-hard look. The chin is rounded and juts forward only about as far as the lips do. Notice, too, that the forehead slopes down at an angle. Some beginners make the mistake of drawing the forehead as a vertical line, which makes the character look like a blockhead. Don't want that. The slightly sloping angle gives him a sleeker look. Let's finish off with the mouth: In profiles, it's usually small and tight. Exceptions are expressions involving smiles or rage, both of which cause the mouth to stretch.

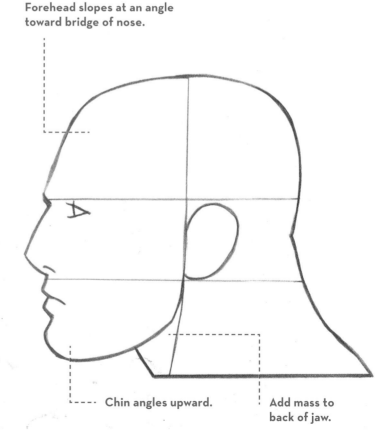

Eye is recessed in head.

Forehead slopes at an angle toward bridge of nose.

Neck slopes forward at 45-degree angle.

Chin angles upward.

Add mass to back of jaw.

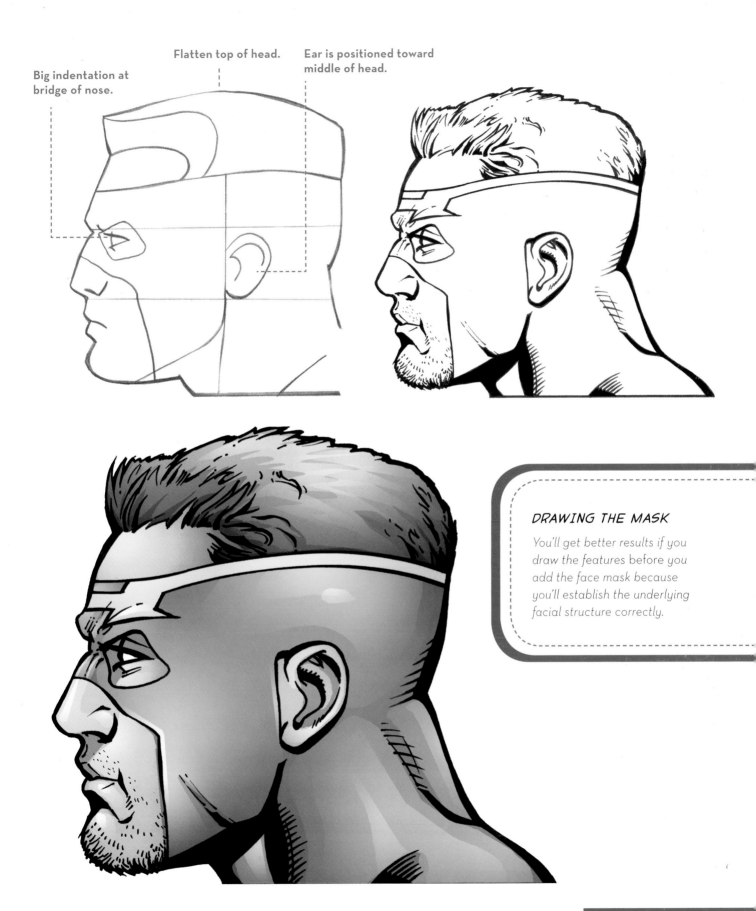

Big indentation at bridge of nose.

Flatten top of head.

Ear is positioned toward middle of head.

DRAWING THE MASK

You'll get better results if you draw the features before you add the face mask because you'll establish the underlying facial structure correctly.

Same basic idea as the guy's head—but much more tapered at the chin. The eyes are not just pointier at the ends but larger than male eyes, too. The eyebrows are higher and arching—and more delicate than a man's eyebrows would be. Also, the eyebrows are not a single, thin line. Beginners often make this error. The eyebrows are of uneven thickness, tapering at both ends. And worry lines? She doesn't have 'em. Angular cheekbones? Only if she's a supervillain. So, just lightly indicate them or omit them entirely. The eyeliner treatment is always emphasized to an extreme and gives her glamour.

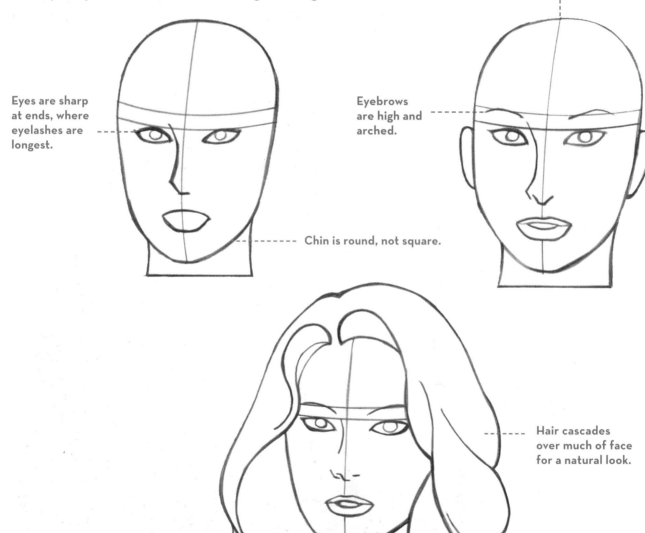

Eyes are sharp at ends, where eyelashes are longest.

Top of head is round, not flat.

Eyebrows are high and arched.

Chin is round, not square.

Hair cascades over much of face for a natural look.

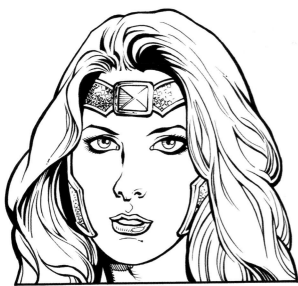

A NOTE ABOUT HAIR

To render the luscious long hair of the comics, don't indicate each and every strand—you'll drive yourself crazy. Instead, block in an overall form for the hair in a preliminary step and then add just a few texture lines as your drawing progresses. And don't block in the hair on the very first step; make sure you establish the head structure first, bald, as it were; then you can block in the hair form.

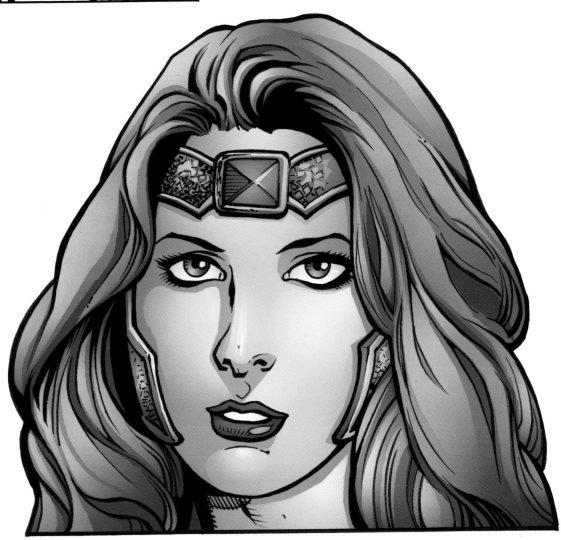

PROFILE

Unlike the man's chiseled profile, the female side view reveals a soft and supple jawline, which connects to a flexible, long neck. A long neck gives her an elegant quality. Both sets of eyelashes are long, upper and lower, but the upper are longest—sometimes even extending past the perimeter of the face. Now for those lips: The lips are drawn oversized, and they protrude somewhat past the chin. It should look like she's almost blowing a kiss.

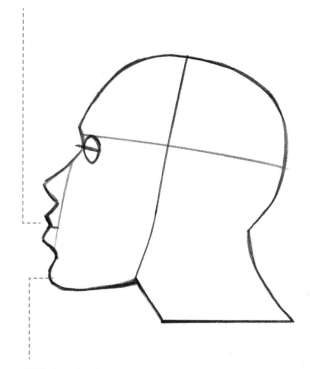

Lips look slightly puckered.

Full chin, but less pronounced than male chin.

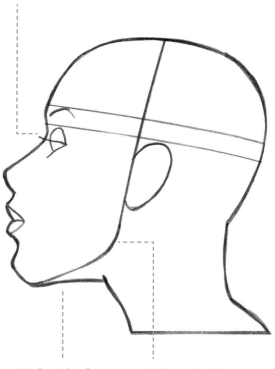

Upper eyelash extends past bridge of nose.

Underside of jaw is soft looking.

High angle of jaw is more feminine.

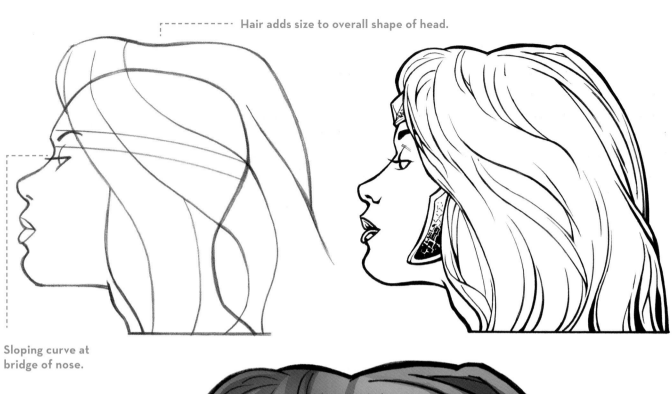

Hair adds size to overall shape of head.

Sloping curve at bridge of nose.

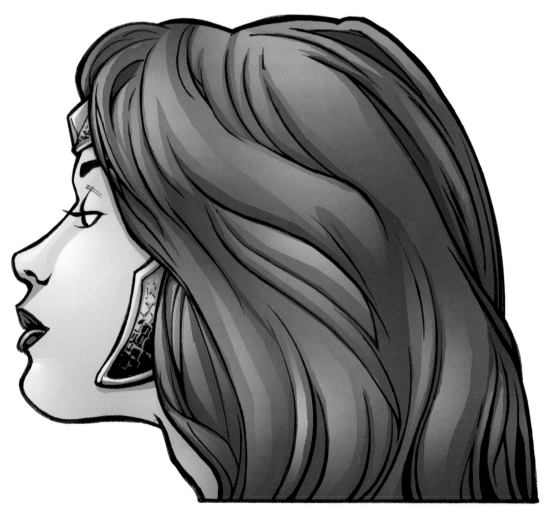

Sharpen those pencils, because we're going to create an assorted cast of great comic book guys, gals, and mutants, the types that star in today's most popular comics—but all original characters. All of these characters are broken down into step-by-step constructions that will help you to visualize the form, planes, and contours of the face. But it's not necessary to draw every contour line you see on each construction step. They're included to show you the concept, which is that different areas of the face have hills and valleys. We indicate these with different planes. In some instances, you may want to follow the steps precisely, and in others, you can skip some steps and go right to the finished stage if you're so inclined. You're the artist.

YOUTHFUL MALE: TEEN SUPERHERO

This young superhero is the type that stars in action-fantasy and sci-fi comics. Don't you love the World War I dogfighter pilot goggles? Hey, everything old is new again. He's a clean-cut type, and bright-eyed. Note how the long, vertical line of shadow on the right side of the face follows the planes that are established in the third step. Typical of youthful characters, our ace pilot has a large forehead and a soft jaw. He's not hard and chiseled looking. The steps here call out the basic facial contours.

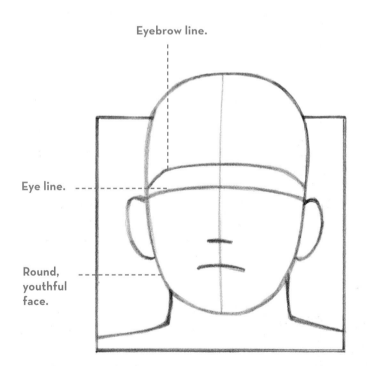

Eyebrow line.

Eye line.

Round, youthful face.

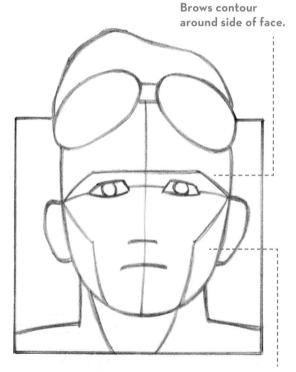

Brows contour around side of face.

Cheeks contour in diagonally from top of ear to bottom of nose.

Shift in planes where forehead curves back.

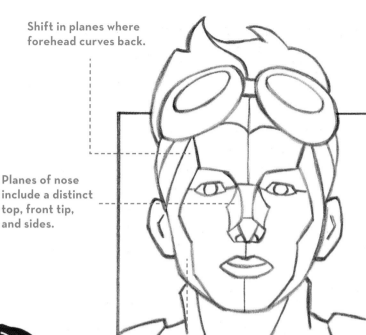

Planes of nose include a distinct top, front tip, and sides.

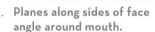

Planes along sides of face angle around mouth.

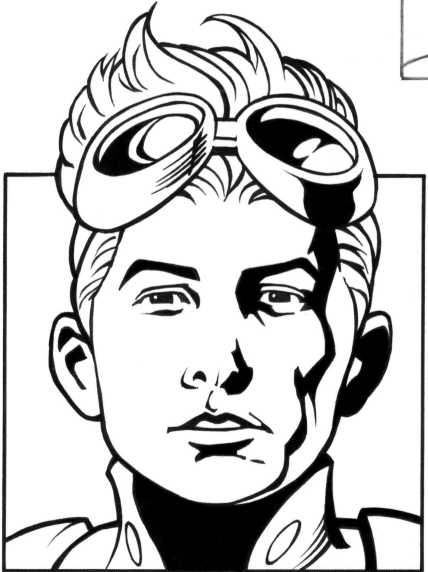

COMIC BOOK RENDERING

Use a simple line to finish the drawing. Then, if you're ambitious, go back and add the comic book–style shading, as shown in the final step. At first, when you start using pools of shadow (the black areas), it may intuitively feel wrong. But it will come together at the end. For example, a single blot of ink, like the blackened ear on this character, is weird by itself. But it's the totality of the shaded areas that makes the final impression on the reader. So keep going. Add that vertical shadow line on his face, the pocket of black at the bridge of the nose, the one under his lower lip, and the cast shadow on his nostril. And watch the character pop off the page.

ADULT MALE: SAVAGE STARSHIP COMMANDER

Older than the teen hero, this character provides an example of adult male facial contours, which are more angular than those of young boys. As our character matures, the bones in his face become more prominent, he loses baby fat, and his skin grows tighter. This results in more defined facial planes. This guy comes from a race of marauders who pillage peaceful settlements all across the galaxy. He's the perfect foe for the young fighter pilot we just saw.

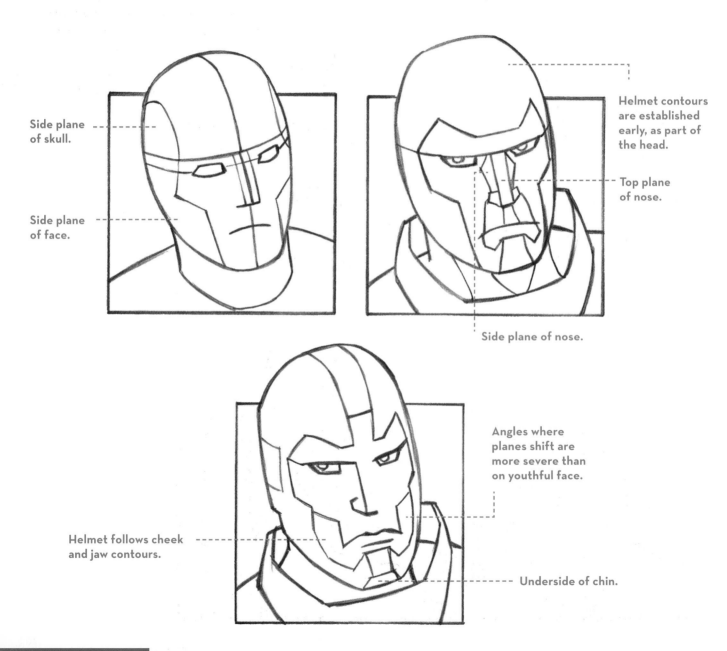

Side plane of skull.

Side plane of face.

Helmet contours are established early, as part of the head.

Top plane of nose.

Side plane of nose.

Angles where planes shift are more severe than on youthful face.

Helmet follows cheek and jaw contours.

Underside of chin.

THE HELMET

Encasing a head in a top-to-bottom metal helmet is a way of dehumanizing a character, making him (or her) seem as much machine as human. The helmet is the character's life-support system, melding with the head into a single biomechanical unit. That, plus the fact that the whites of his eyes are black (that white area you see here is the iris), gives him a cruel, otherworldly appearance. As you can tell from his expression, it's not a good day to ask him for a raise.

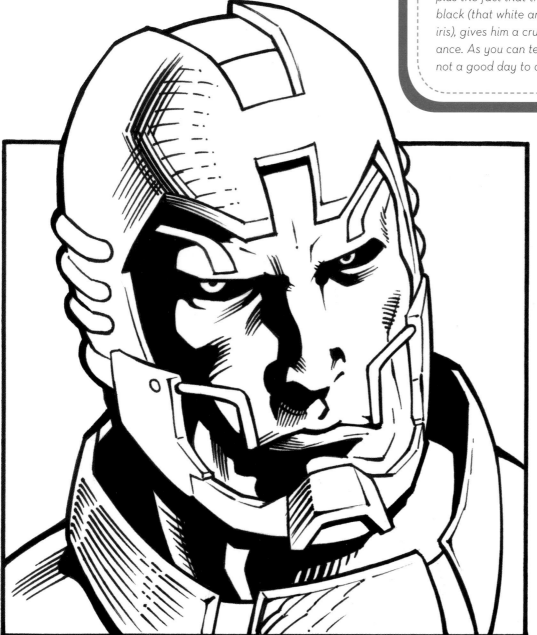

3/4 VIEW: SCI-FI ALIEN QUEEN

In the 3/4 view, the contours of the face are most visible along the far perimeter of the form. That is where you see the angles. The same holds true for younger female characters.

And talk about exotic women! This devil-eared beauty is the leader of a race of aliens. Sci-fi is where character designs mix primitive and futuristic motifs to produce enchanting, fantastical characters. The queen from a distant planet, seductive and alluring, is an ever-popular standard in comics.

The sharp eyebrows, with a high arch, add a wicked flourish to her expression. The ear is made to stand out by the accessories, which serve to draw attention to it. The headdress has hornlike prongs to repeat the theme of the pointed ears. Repeating themes is one way artists create a cohesive character design.

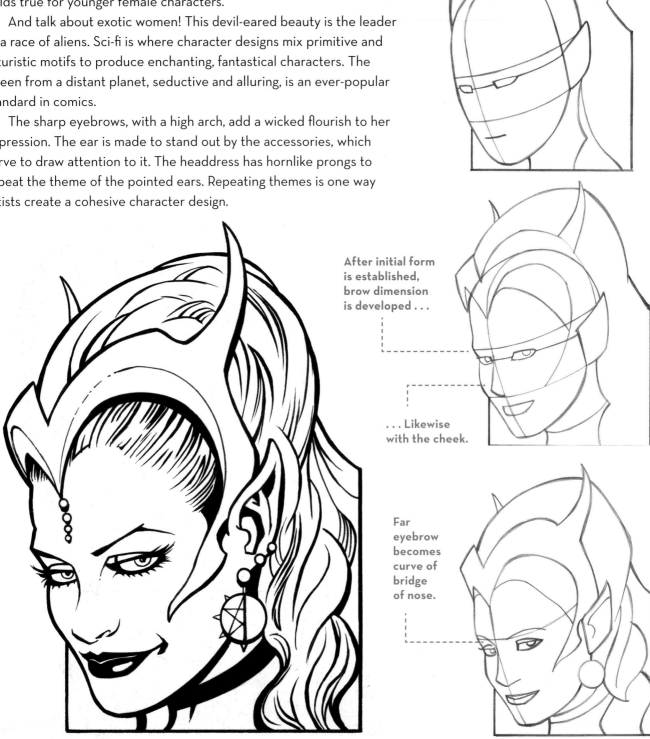

After initial form is established, brow dimension is developed . . .

. . . Likewise with the cheek.

Far eyebrow becomes curve of bridge of nose.

3/4 VIEW WITH INTERIOR SHADING: THE NEW LOOK OF CRIME

In addition to the contours on the perimeter of the face, shadows are used to show the planes on the inside of the face, within the perimeter.

The old-style, fat, cigar-chewing crime boss has been replaced with a new, sleeker character. He's younger and more ruthless than his predecessor. There's no family code of honor among these thieves. They're into arms smuggling and international intrigue. They don't deal in handguns but in missile launchers, and they sell to the highest bidder. Never to be trusted, not even by their closest associates, the double cross is in their blood.

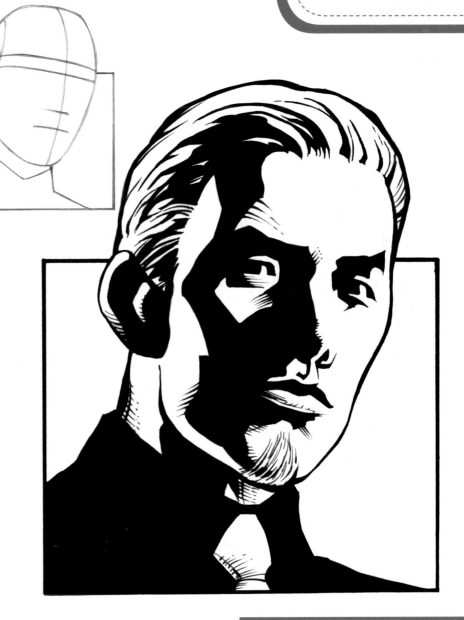

Comics are filled with close-ups and extreme close-ups, in which the features are drawn in great detail—and in a distinct comic book style. Sometimes the eyes or the mouth are the only element in a panel. Or, the close-up of the face might be so tight that each feature needs to be very carefully drawn. Comic book artists draw close-ups of the features with the same attention to detail that they would give to drawing an entire face or body. Spend a little time copying these shots. They'll give you the chance to really focus on the features in a way that you never have before. They're designed to bring out the comic book artist in you.

EYES

The eyes communicate a character's inner thoughts. Obviously, thoughts like "Why does my wife always ask me to pick up her things at the cleaners?" are beyond our ability to express merely by virtue of a glance. And who wants to learn that a superhero does chores anyway? But primitive thoughts like "I'm out for revenge" or "Please . . . God . . . No!" can, and should, be conveyed with a single flash of the eyes.

In addition, the way you draw the eyes determines the character's identity. For example, beady eyes are used for villains. Large pupils connote innocence and youth. Almond-shaped eyes with heavy eyelashes make for attractive, female characters. Rectangular eyes, with heavy eyebrows, are often seen on heroes.

It's also important to be aware that the movement of the eyebrows affects the shape of the eye. For example, as the eyebrow crushes down on the eye in a scowl, the eye itself becomes narrower. When the eyebrow lifts up in a surprised look, the eye opens up, becoming rounder. And note that you don't have to show the eyes on every character: Don't forget about eye patches, cool visors, goggles, and cyborg eyepieces. Eye masks are sometimes drawn with "empty" eyes that leave out the pupils for an otherworldly, awesome look.

Piercing, for Men

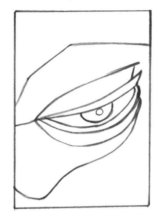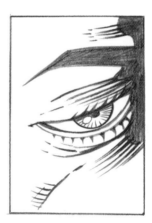

In the *down angle* (meaning we're looking down at the character from above), the sides of eyelids curve upward, indicating the round form of the eyeball under the lids and within the eye socket.

Alternately, in the *up angle* (meaning we're looking up at the character from below), the eyelids curve downward to the sides, again indicating the round form of the eyeball under the lids and within the socket.

The eyebrow has mass and depth, as indicated by different planes; it's not just a line.

In profile, set the eye back from the bridge of the nose. Note how, as mentioned, a furrowing brow alters the shape of eye.

Sultry, for Women

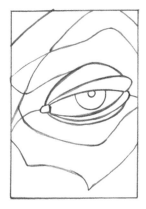 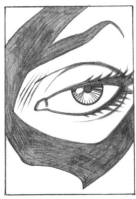

The top and bottom eyelids have the thickest lines, with eyelashes that brush away from the eye. Most important for the seductive look is the placement of the upper eyelid on the iris and/or pupil; the eyelid rests low on the iris, sometimes even cutting off part of the pupil. The eyebrow should have a high arch.

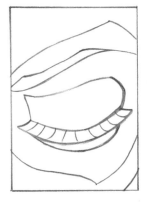 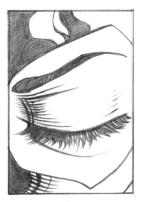

Just as with men, in the down angle, the eyelids curve up to the sides—even when the eye is closed.

 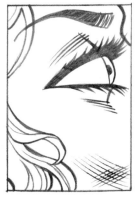

The front of the eye is round, not flat, so remember to render it this way in profile.

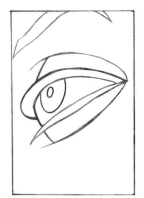 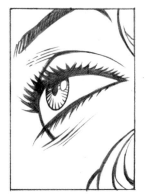

In the up angle, the eyelids curve downward to the sides—even in profile and 3/4 views.

THE NOSE

The nose is formed from a series of planes intersecting at different angles. It has mass and depth. Most beginning artists only draw one line to indicate the bridge of the nose. But you can't show mass if you only use one line. Give the bridge of the nose some thickness, as seen in front and 3/4 views. And remember, since the nose protrudes from the face, it casts a shadow on the upper lip.

CROSSHATCH SHADING

Crosshatching is another shading technique that is often used as a precursor to solid black shading. It indicates an area that's getting darker.

Articulated, for Men

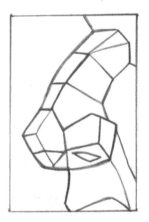
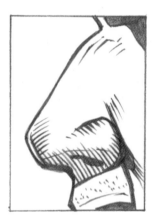

The nose has a top and a side to it, which is something you should keep in mind even in the profile to achieve the most convincing drawing.

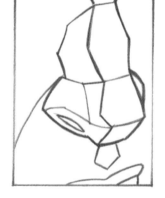

Again, note the planes of the bridge, tip, and nostrils, as well as the shadow cast by the nose onto the upper lip. Without this shadow, the drawing would look much less dimensional.

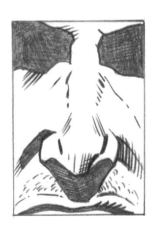

The bridge of the nose widens out slightly in the middle, and as mentioned, the tip of the nose casts a shadow that helps to convey form and three-dimensionality. The shadows in the creases around the nostrils also do this.

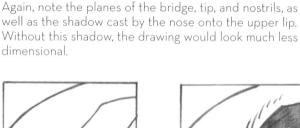

The nostril openings are not simple circles. The contours and planes that form the tip of the nose affect the shape of the opening, causing it to taper toward the tip. This pose is not as uncommon as one might think. We often look up at heroic characters.

Subtle, for Women

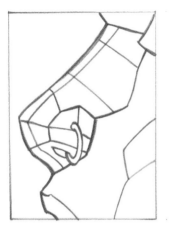 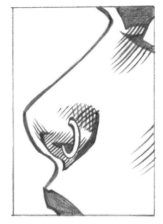

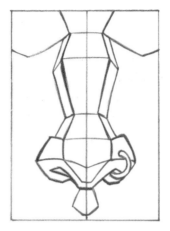 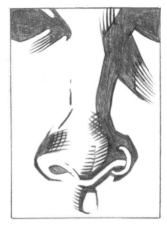

The lips and eyes—not the nose—should be the focus of the female face. So our job is to draw the nose subtly so that it doesn't draw attention to itself.

The bridge of the comic book woman's nose is thin, and some artists even leave it out altogether, just drawing the nostrils. If you do include it, use subtle, less-evident construction than what you see on male characters. Shade one side plane of the nose to highlight its narrow sleekness. When you do this, keep in mind which side your light source is coming from (see page 120 for more on that).

 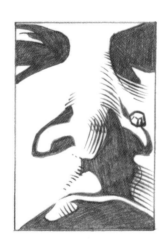

 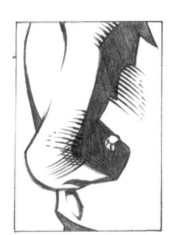

Use shadow, rather than a hard line, to show the bridge of the nose, softening the look. Note that in the up angle, the tip of the nose is most prominent.

The nostrils must be kept small, likewise the tip of the nose.

THE MOUTH

The mouth and the eyes don't have to "sync up" to make great expressions. In fact, often they are doing opposite things. For example, a combination of angry eyes and a gleeful smile creates a look of evil delight. A combo of sad eyes and a smile creates an expression of caring. Giggling (closed) eyes can be used in combination with mouths that are laughing, crying, or grimacing. So the mouth works independently of the eyes.

The mouth has a band of muscles that encircles it (the orbicularis oris). When showing teeth, draw lips pulled back *around* the teeth. Don't draw the opened mouth as a straight line; remember that the teeth are formed along a curve.

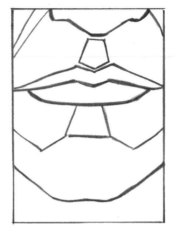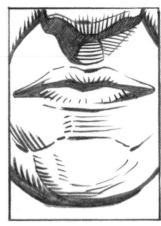

A stretched-open mouth is accompanied by stretch lines on the face.

Expressive yet Forceful, for Men

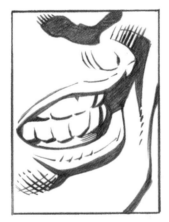

The mouth pulls back at either side to form expressions.

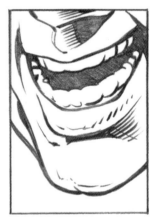

The mouth wraps around the teeth, which progress back into that mouth in a curved arrangement (not straight across) because they fall on the jawbone, which itself is a curved structure.

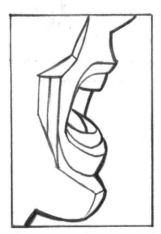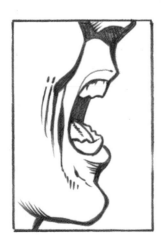

Observing the lips in a neutral position lets you see the basic plane structure and how to indicate it with shading.

Expressive yet Feminine, for Women

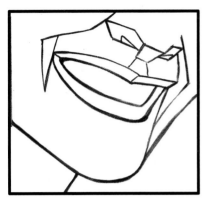

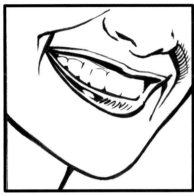

THE EAR

Ears are like snowflakes in that no two are identical. And even if the ear you draw looks a little weird, who's to argue? Ears are already weird looking!

Two circles form the basic structure. Note the size relationship of the circles to each other and to the third divisions.

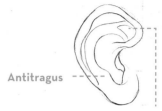

Antitragus

Fossa triangularis

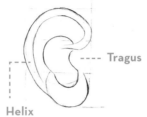

---- **Tragus**

Helix

And don't forget either the little "hiccup" called the antitragus or the "fork in the road" that's apparent on all ears, the fossa triangularis.

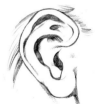

The edge (the helix) winds around the rim and, at its forward-most end, doubles back over the "ear flap" (the tragus).

The teeth are indicated, but each tooth isn't completely drawn in. Some of the defining lines between the teeth are only partially articulated, allowing the teeth to blend together to some extent. This creates a gleaming, brilliant look. Note how the upper lip actually travels downward toward the corners in a smile.

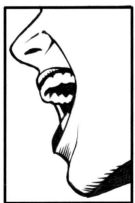

Note that in certain views and expressions you see both the inner and outer sides of the teeth.

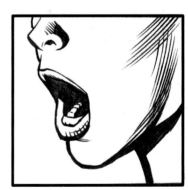

The mouth and can "shrink" or "expand" for certain expressions. The lips are usually drawn in different thicknesses. In other words, either the top lip is fatter than the bottom or vice versa. Rarely are they the same thickness. This asymmetry adds to the allure. This character has a heavier bottom lip, but an oversized upper lip is also an attractive look.

In order to sustain a 32-page story, comic book characters must have developed personalities and a wide emotional range. Good guys aren't always ruggedly determined. And villains aren't always laughing with evil delight. Those are requisite emotions and expressions, of course; however, to breathe life into characters, you must make them more than one-dimensional. That means that insecurities and frustrations also dog superheroes, just as they do us mortals.

On these next few pages, you'll find the classic expressions you need to create most situations in comics. Each expression is drawn at different angles in which you're likely to draw your characters. Note that some of the images on page 33 are sketchier than the ones here. This gives you an idea of the range of drawing styles across the different stages of a project: usually sketchier at the start and more "shored up" as things develop into the end result.

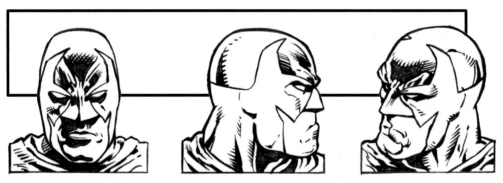

Determined

This is the most popular expression for the single-minded superhero. Note the tight bottom lip and jutting chin.

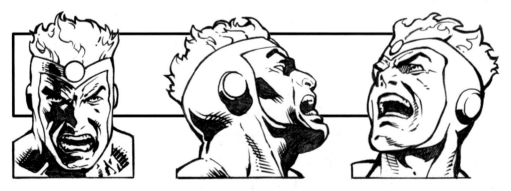

Furious

It's the springboard emotion that propels both superheroes and villains to seek revenge—open mouth, teeth evident. Histrionic villains make great characters. They don't bother to keep their feelings bottled up. Note the flared nostrils.

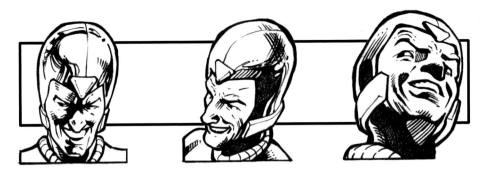

Scheming

A great expression for villainous characters, note the narrow eyes with the sidelong glance.

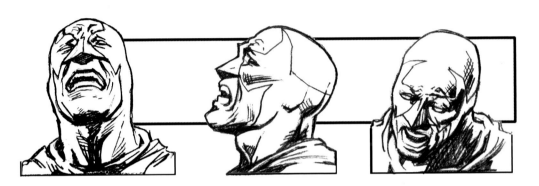

Grief Stricken

Superheroes grieve over the loss of a loved one just like everybody else. Note the open mouth, with the two rows of teeth set close together.

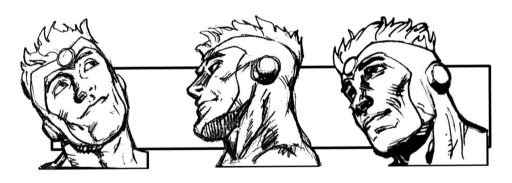

Having a Pleasant Thought

Lighter moments should punctuate the story, albeit infrequently, so that it doesn't become too morose. In this expression, the character looks up and to the side, as if "seeing" the thought in his mind's eye.

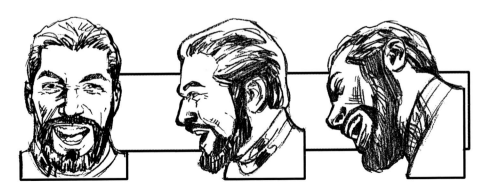

Laughing

Another lighthearted moment. Note how the crease under the eyes pushes upward.

Brooding

There's a lot of speech between characters in comics. Don't let the speech balloon do all the work for you; your character's expressions must reflect what's being said and felt. Note the furrowed brows and tight mouth.

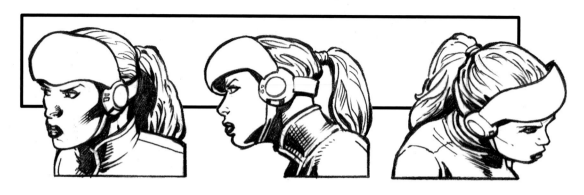

Amazed

This is a good expression when your character witnesses something spectacular, like a superhero saving someone in the nick of time. Note the wide-eyed expression combined with the wide-open mouth.

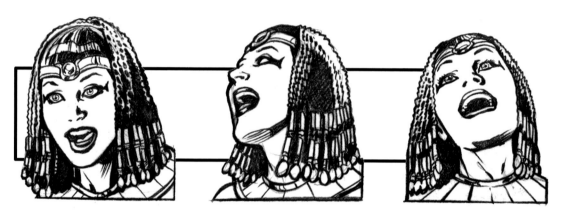

Stunned

Here, the mouth opens even wider than in the amazed expression, but without the hint of a smile. Use this one when, for example, your character sees the size of the powerful robot killing machine that the villain has unleashed on the city!

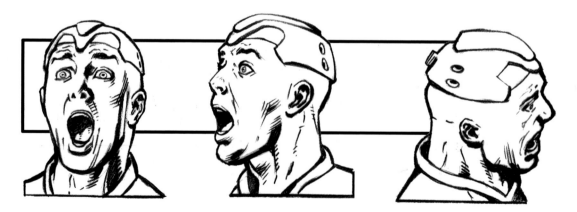

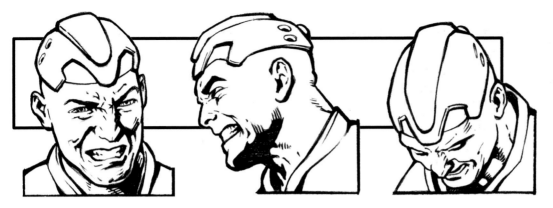

Fighting Mad

There's hardly a comic book in print that hasn't featured this expression in one of its stories. Grit the teeth and wrinkle the bridge of the nose.

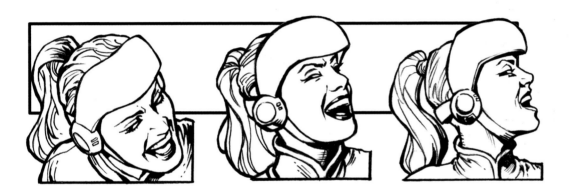

Sinister Smile

That's the diabolically delicious part about villainous characters: They enjoy evil so much. This expression combines a big smile with angry eyes.

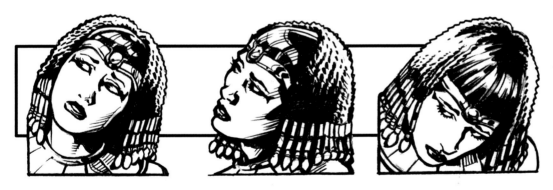

Remorseful

A slight tilt of the head works well to indicate the regretful state of the character. Sad eyes combine with a pensive mouth. This is for poignant moments. So the mouth is slightly open with downward-turned edges and the eyes show concern.

The SUPERHERO BODY

To get a good handle on drawing the figure, we'll start off with the basic anatomical foundation for your characters. This makes great reference material for your files. We'll then quickly move on to how to simplify the figure so that you won't get bogged down with muscle charts and skeletons. Finally, we'll put it all together, drawing full superhero figures, in costume, from the step-by-step tutorials provided.

THE SKELETON INSIDE THE FORM

It's not just the muscles but also the *skeleton* that gives the body its impressive stature. For example, if the character has wide shoulders, a deep chest, and a narrow waist (the typical superhero build), then this is formed by widely positioned scapulas (shoulder blades), broad clavicles (collarbones), an enlarged rib cage, and a small pelvis.

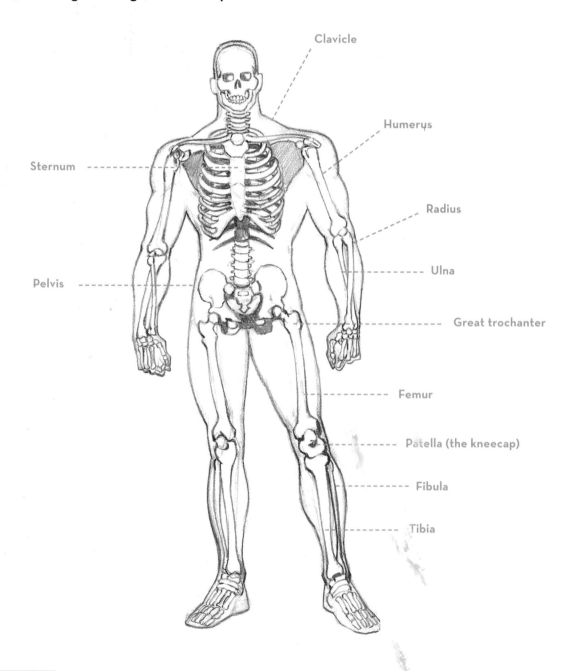

Clavicle

Humerus

Sternum

Radius

Ulna

Pelvis

Great trochanter

Femur

Patella (the kneecap)

Fibula

Tibia

**Scapula
(the shoulder blade)**

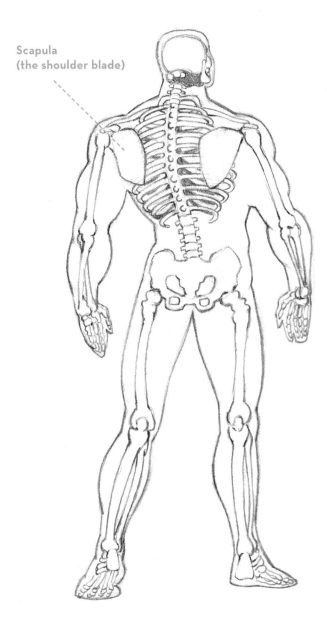

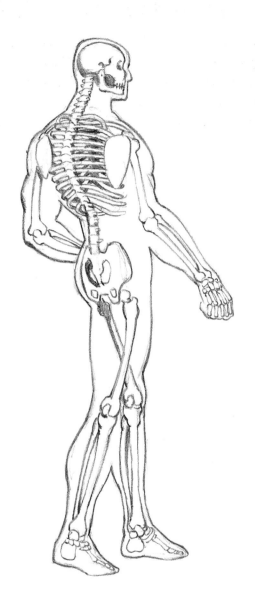

The leg bones are heavier and, therefore, thicker than the bones of the arms. They have to be sturdier, because they're supporting all the weight of the body. The spine is thickest by the pelvis and gets thinner as it travels up toward the neck.

The bones of the body are not "ruler straight." This is why you'll detect a slight curve to the arms, legs, and collarbones in these diagrams. This curving is what gives life to the body. Only beginners draw arms, legs, and collarbones perfectly straight. Even the spine—*especially* the spine—has a natural curve to it.

THE MUSCLES

An anatomical muscle chart, featuring the rippling, pumped muscles of the classic superhero, is essential for the comic book artist. Everyone, regardless of how experienced he or she is in drawing, goes back to reference material now and then. At first, you may want to have the book flipped open to this page whenever you're drawing superheroes; but after a while, it will eventually become second nature to you. Don't worry about the Latin names for the muscles. Just eyeball them, and try to approximate the definition. This one just takes practice, and a little patience.

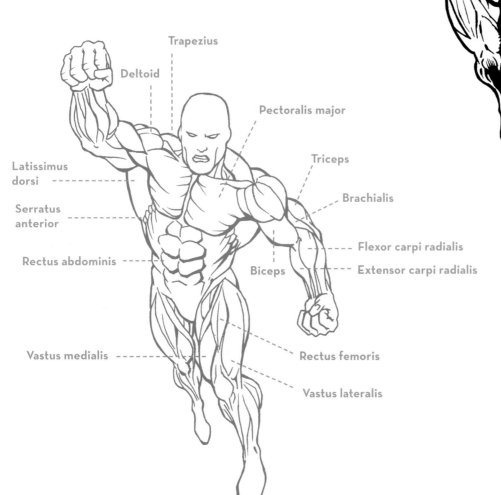

Trapezius

Deltoid

Pectoralis major

Triceps

Brachialis

Latissimus dorsi

Serratus anterior

Flexor carpi radialis

Extensor carpi radialis

Rectus abdominis

Biceps

Vastus medialis

Rectus femoris

Vastus lateralis

This costumed figure has been superarticulated so that each muscle group can be seen; however, it's not necessary to detail every single muscle in every single pose. For example, the forearm doesn't have to be flexed and ripped all the time. Only the main muscle groups are chiseled continuously: pecs, abs, lats, biceps, triceps, and quads. The others are flexed as warranted by specific actions.

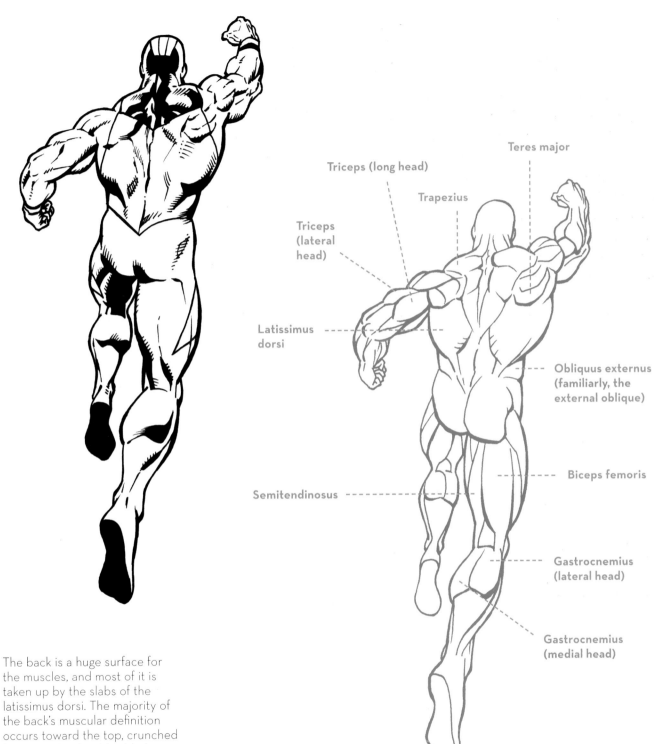

Triceps (long head)

Teres major

Trapezius

Triceps (lateral head)

Latissimus dorsi

Obliquus externus (familiarly, the external oblique)

Biceps femoris

Semitendinosus

Gastrocnemius (lateral head)

Gastrocnemius (medial head)

The back is a huge surface for the muscles, and most of it is taken up by the slabs of the latissimus dorsi. The majority of the back's muscular definition occurs toward the top, crunched between the shoulder blades and close to the spine.

SIMPLIFYING THE BODY CONSTRUCTION

Now that we've covered some anatomical intricacies of drawing the muscles, we'll go over the broad strokes—how you actually begin your comic book figure: First, simplify, then work in the advanced musculature.

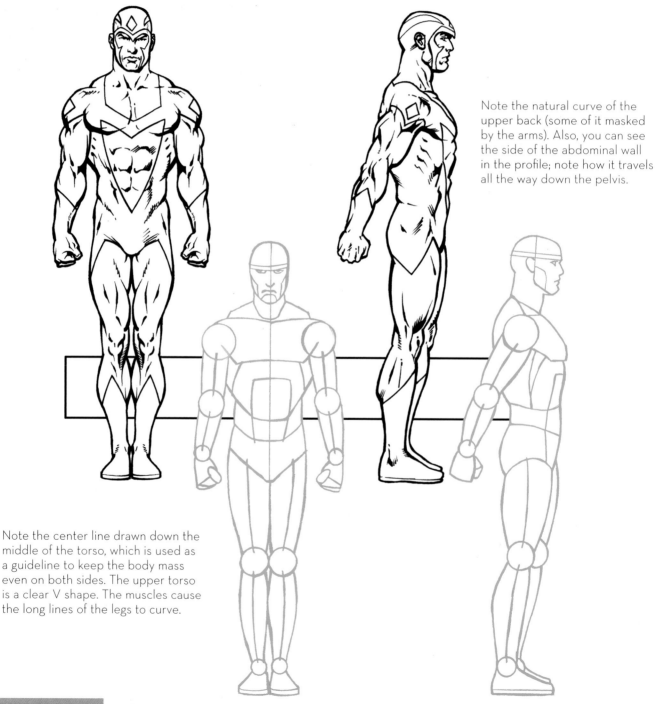

Note the natural curve of the upper back (some of it masked by the arms). Also, you can see the side of the abdominal wall in the profile; note how it travels all the way down the pelvis.

Note the center line drawn down the middle of the torso, which is used as a guideline to keep the body mass even on both sides. The upper torso is a clear V shape. The muscles cause the long lines of the legs to curve.

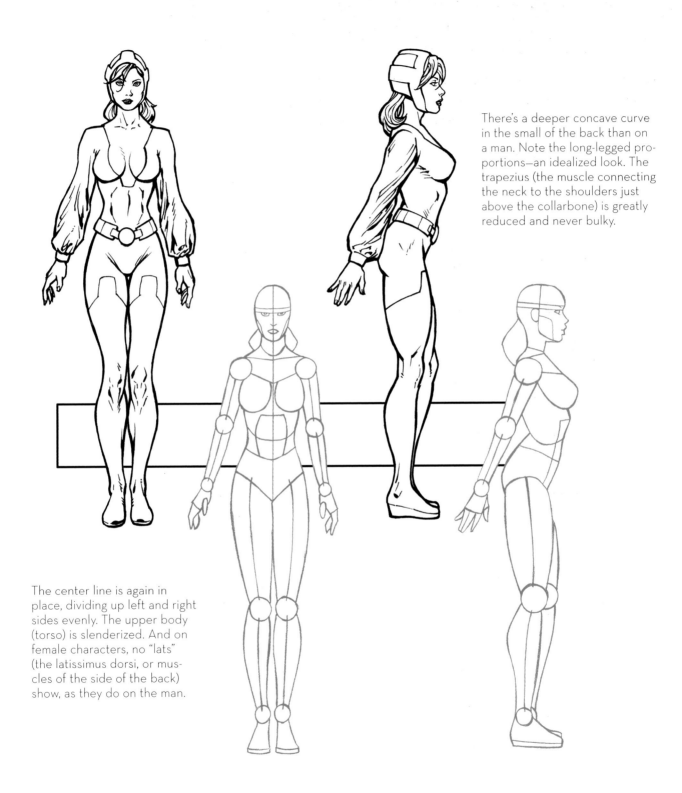

There's a deeper concave curve in the small of the back than on a man. Note the long-legged proportions—an idealized look. The trapezius (the muscle connecting the neck to the shoulders just above the collarbone) is greatly reduced and never bulky.

The center line is again in place, dividing up left and right sides evenly. The upper body (torso) is slenderized. And on female characters, no "lats" (the latissimus dorsi, or muscles of the side of the back) show, as they do on the man.

HANDS

The fingers create the "expressions" of the hand. They flex, point, and extend with great yearning. Each finger has three joints, which means it will have three bends in it. The thumb has three joints also, but only two are visible. The knuckles on men are always articulated (emphasized). Most people who draw give the heel of the thumb ample mass, but also remember that the palm heel is a large pad, too. And when the hands are drawn in medium or close-up shots, you can add fingernails. When they're part of a smaller figure, it's best to leave the fingernails off.

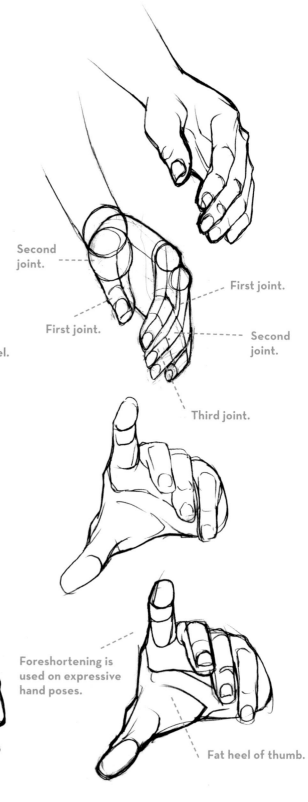

Second joint.

First joint.

First joint.

Second joint.

Third joint.

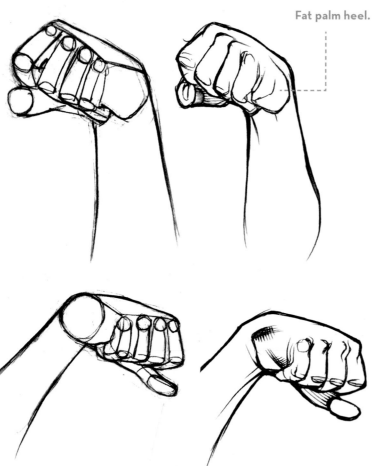

Fat palm heel.

Foreshortening is used on expressive hand poses.

Fat heel of thumb.

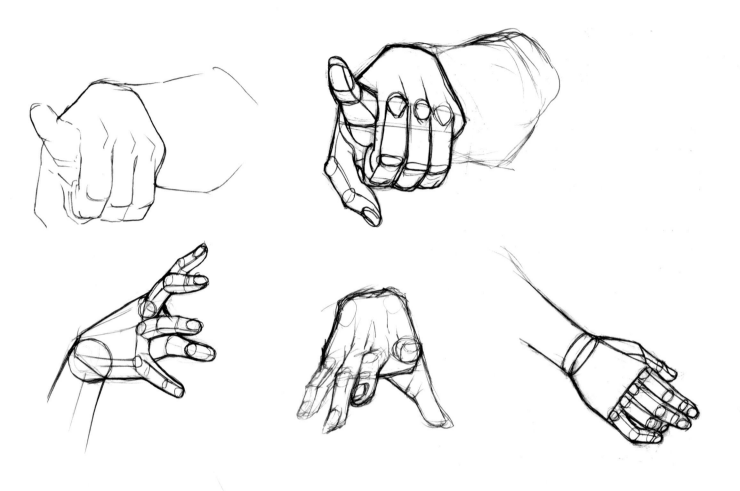

FISTS

Fists are great mallets, used to pound bad guys into submission. Fingers get a little tricky to draw when they're wrapped around the palm into a tight fist; it's important to be sure that you're indicating each finger joint in the fist. If the fist looks wrong, count up the joints on the fingers. Are you showing three distinct angles to each digit? If not, you left out a joint.

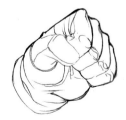
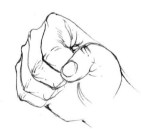

FEET AND FOOTWEAR

Feet. All characters have them, but no one likes to draw them. So I've included drawings of feet in all sorts of positions, which you can use as a chart to eyeball anytime you need a reference. Then there are feet in footwear: superhero boots, regular shoes and boots, and high heels. Designing superhero boots is like designing any part of a comic book character's costume: You've got to make it dramatic. Add buckles, cuffs, jewels, armor plates, an insignia, or decorative trim.

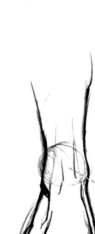

"Bump outs."

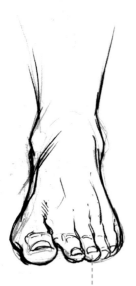

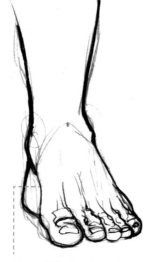

Instep has considerable height to it. Don't draw feet too slender!

Achilles heel tendon is visible in rear view.

Line of big toe travels up to inner ankle.

Big toe can stand alone, but always group four smaller toes together.

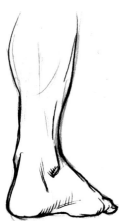

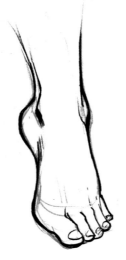

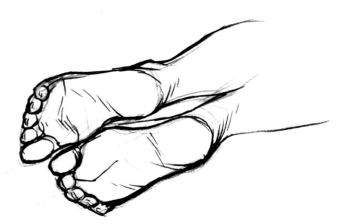

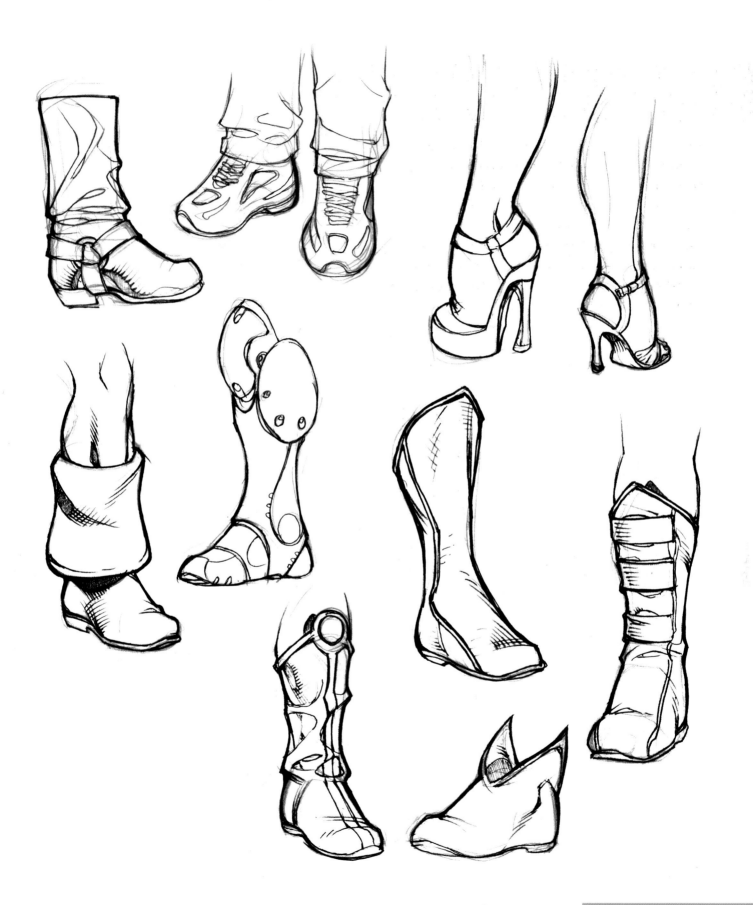

CHAPTER **3**

Comic Book
FORESHORTENING
& Body Dynamics

All successful comic book artists have something in common: They make consistent use of foreshortening, and they understand the dynamics of the figure in motion. To start, the effective use of foreshortening is what separates the advanced artists from the beginners. It adds extra power to poses, and if you've read any comics at all, you've seen this technique hundreds of times in extremely dramatic poses and also adding "oomph" even to regular poses. So it's time you started using it more.

When combined with the use of foreshortening, an understanding of the forces affecting the body as it moves through space allows for the most convincing representation of action—and of the figure in general. Whether the body is standing, leaning, or balancing on one limb, the comic book artist exaggerates these dynamics (using foreshortening) to make poses more dramatic. This attention to body dynamics is an essential tool in your arsenal of comic book techniques.

FORESHORTENING BASICS: YOU'RE NEVER "JUST STANDING THERE"

Foreshortening is a technique involved in the representation of perspective. It's simple, actually. The laws of perspective tell us that objects that are closer to us appear larger than those that are farther away. Everything shows the effects of perspective to some degree. So when you translate this principle to comic book illustration, all it means is that you exaggerate the size of the parts of the figure (or the scene) that are closer to you (bigger) and reduce the size of the parts that are farther away (smaller) in the drawing. In doing this, you want to compress the forms a little bit, which you can do by drawing elements of the figure shorter than they would otherwise be and also overlapping one another. Some foreshortening poses require eliminating parts of the body that are overlapped by other parts. Maybe your character has raised his knee and we can't see his foot underneath, for example. That's a simple form of foreshortening. Starting with a basic heroic standing pose, the next few poses will cover a group of classic comic book poses that use foreshortening. But you'll also see foreshortening in most poses throughout the book.

So let's start with the classic heroic stance. This may seem like a basic pose, but again, *everything* shows some effect of foreshortening. The superhero *never* just stands there facing the reader head-on. You want him to look noble, even triumphant, so you draw him in a slight "up angle" (meaning we're looking up at him from a lower viewpoint). And since we're looking up at him—instead of straight-on in a flat, neutral angle—some foreshortening is required to make this angle effective: The legs are larger, because they're at our eye level (we seem to be looking directly at them, not down or up at them). Then the upper body is truncated slightly, meaning it's not as long as it would otherwise be. And the head, being the farthest part from us as we look up at it, is smaller still.

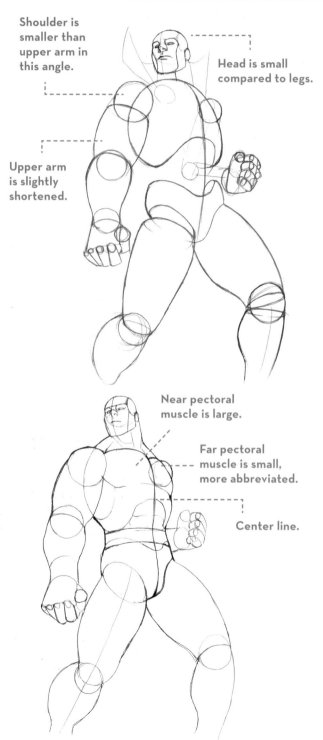

Shoulder is smaller than upper arm in this angle.

Head is small compared to legs.

Upper arm is slightly shortened.

Near pectoral muscle is large.

Far pectoral muscle is small, more abbreviated.

Center line.

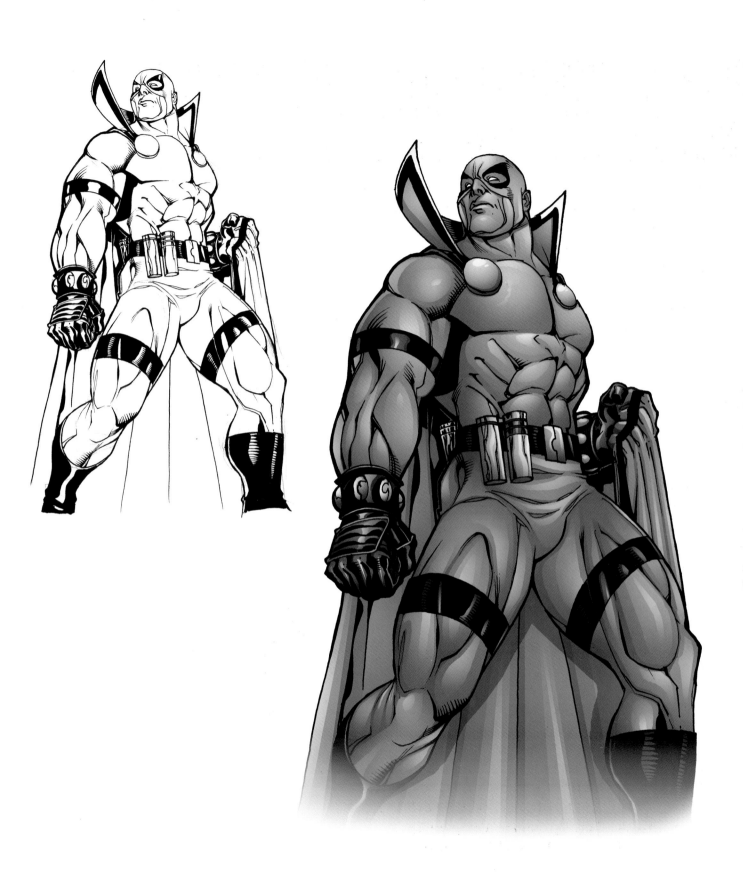

FLYING AT US

Here's another classic comic book pose if there ever was one. Instead of drawing him flying left to right across the page, you'll get much more power in the moment by having him fly toward the reader, who almost has to duck out of the way! You can open his hands if you want, but closed fists make a cooler, more modern look—and it also saves you the agony of drawing open hands in perspective.

Note how much overlapping is going on with the arms. They've "flattened out" due to foreshortening, yet all the muscles that we can see are still defined. His head is lowered onto the shoulders, which means we can't see his neck at this angle. And the legs are eliminated below the knees.

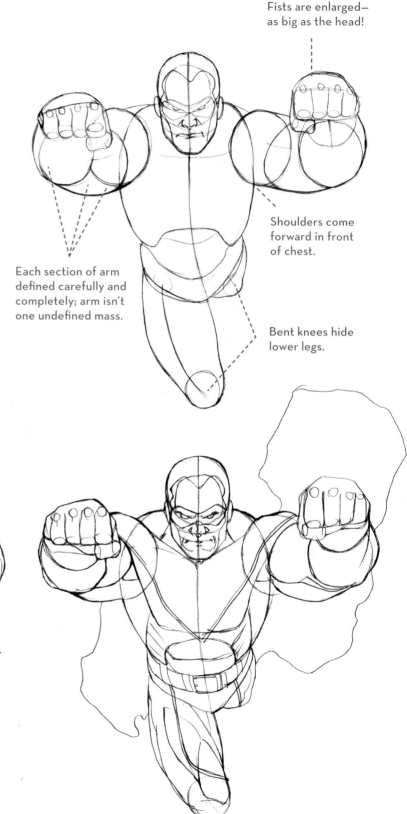

Fists are enlarged—as big as the head!

Shoulders come forward in front of chest.

Each section of arm defined carefully and completely; arm isn't one undefined mass.

Bent knees hide lower legs.

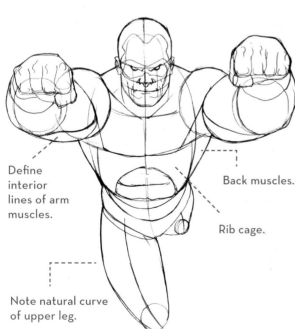

Define interior lines of arm muscles.

Back muscles.

Rib cage.

Note natural curve of upper leg.

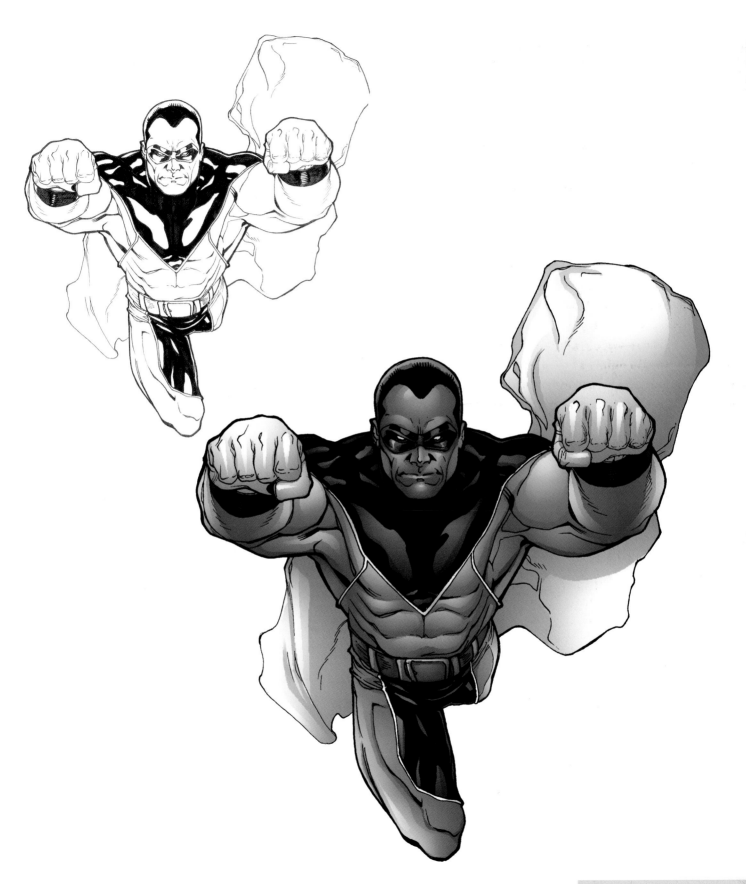

SWINGING AND LEAPING

Whether swinging from a rope, preparing to release a flying kick, or simply jumping off the top of an 18-wheeler cruising down the freeway, a leaping (or otherwise airborne) character is always dramatic. When a character swings or leaps she gets some height, so draw her as if she's above the reader, at an "up" angle. Most of the foreshortening occurs in the front leg, which is coming toward the reader. Notice that the upper thigh of the front leg is very short. Compare this to the far leg, which, because it's not coming toward us but is parallel to us, is not foreshortened. The same deal with the bent arm. Her straightened arm, however, isn't parallel to us but angling toward us at 45 degrees. Therefore it is affected by foreshortening; however, since it's not coming directly at us, the foreshortening is less severe here than it is on the near leg. But still, note how truncated the foreshortened forearm is. Also, since we're looking up at her from below, the head is diminished slightly in size, because it appears farther away from us.

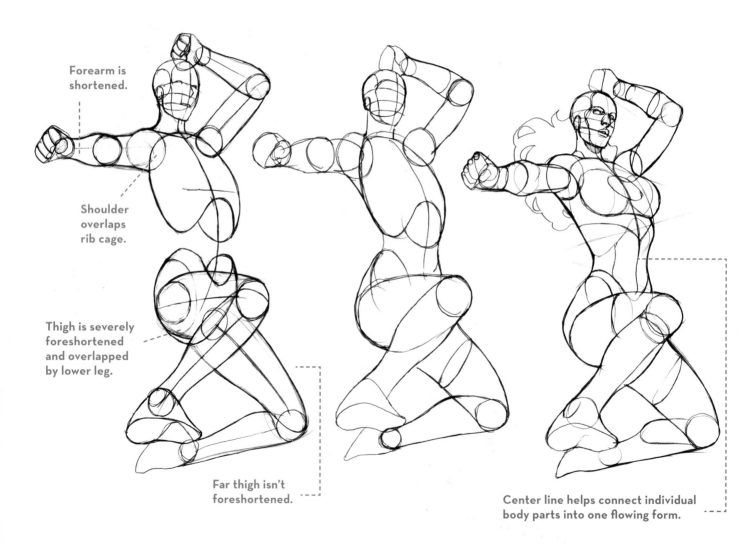

Forearm is shortened.

Shoulder overlaps rib cage.

Thigh is severely foreshortened and overlapped by lower leg.

Far thigh isn't foreshortened.

Center line helps connect individual body parts into one flowing form.

INDICATIONS FOR THE INKER

The penciler marks the areas to be filled with black with and X so that the inker knows what to aim for.

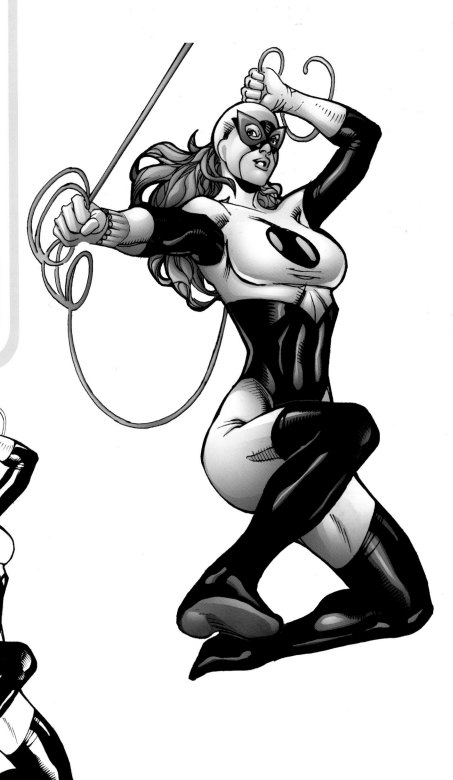

THE RUNNING PUNCH

This is absolutely classic foreshortening action. One arm is out right in your face, one arm is back. The bent leg is driving forward, the other is back. The front fist is bigger than his entire head! The far fist, by contrast, is smaller than the head. So you can begin to see that there are no fixed sizes to the body parts in a foreshortened pose. You exaggerate parts depending on how much impact you want and how much exaggeration you can impart before the pose loses its feeling of reality.

In the running punch, remember to have the arms swinging in the opposite directions of the legs on the same sides of the body, just as in a walk or a run. So on the side with the punching arm, the leg is in the back position. On the side with the forward-moving bent knee, the arm with the fist is coiled back, ready to deliver a follow-up blow.

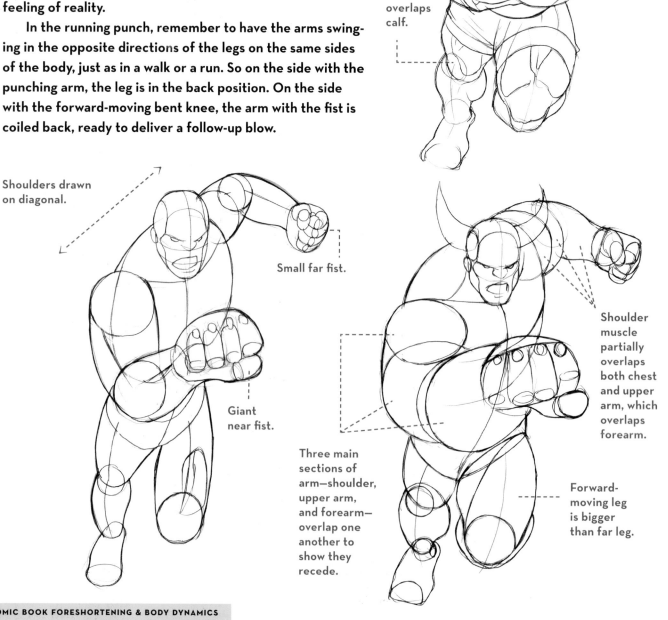

Shoulder is made up of three muscle sections.

Knee overlaps calf.

Shoulders drawn on diagonal.

Small far fist.

Giant near fist.

Three main sections of arm—shoulder, upper arm, and forearm—overlap one another to show they recede.

Shoulder muscle partially overlaps both chest and upper arm, which overlaps forearm.

Forward-moving leg is bigger than far leg.

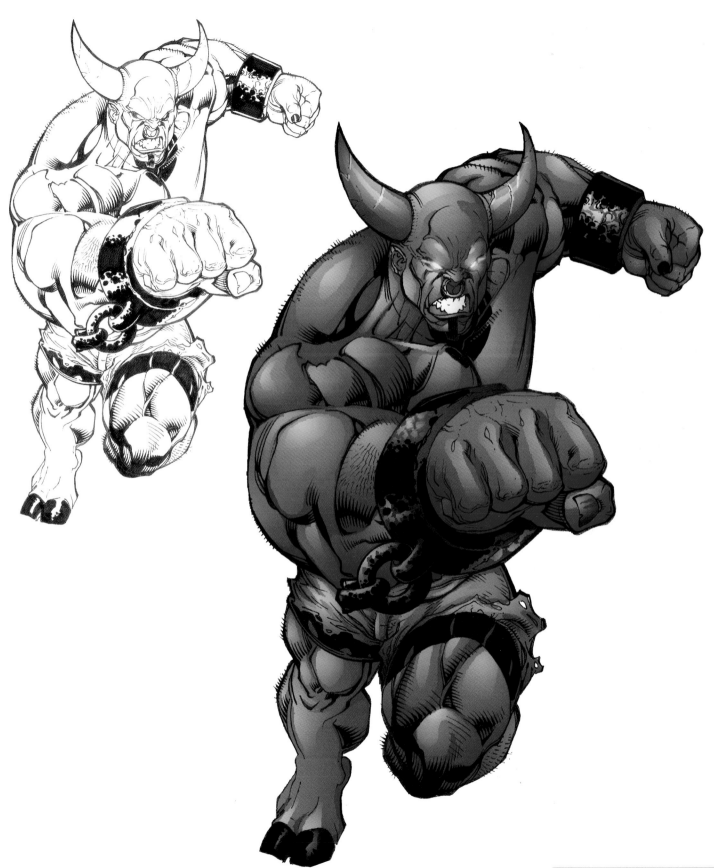

GETTING SOCKED!

Throwing a punch isn't the end of a fight scene—you've also got to draw the guy who's reeling from the blow. Rather than send this poor guy careening into the background, show him falling forward into the foreground. That'll wake up the reader! Notice that his entire body goes limp as he receives that haymaker. His head leads the way, with his arms and legs coming in tow, a beat behind due to inertia. The top half of his body is enlarged, while the bottom half is reduced in size. Note how his midsection is shortened as his chest takes prominence in the picture.

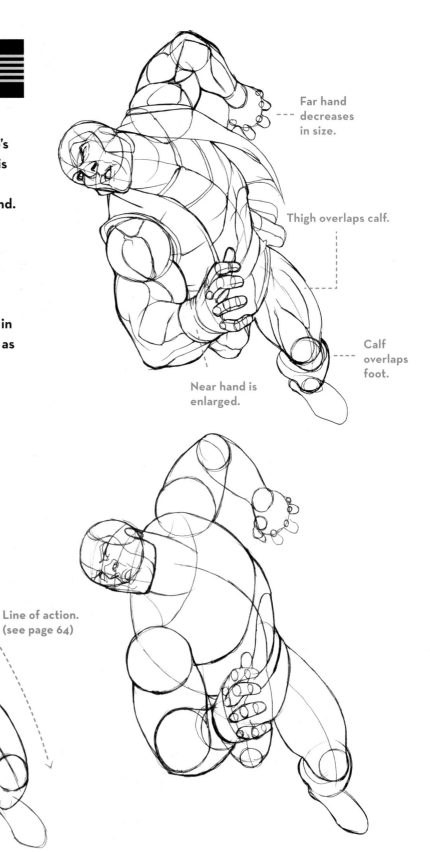

Far hand decreases in size.

Thigh overlaps calf.

Calf overlaps foot.

Near hand is enlarged.

Line of action. (see page 64)

Rib cage overlaps hips.

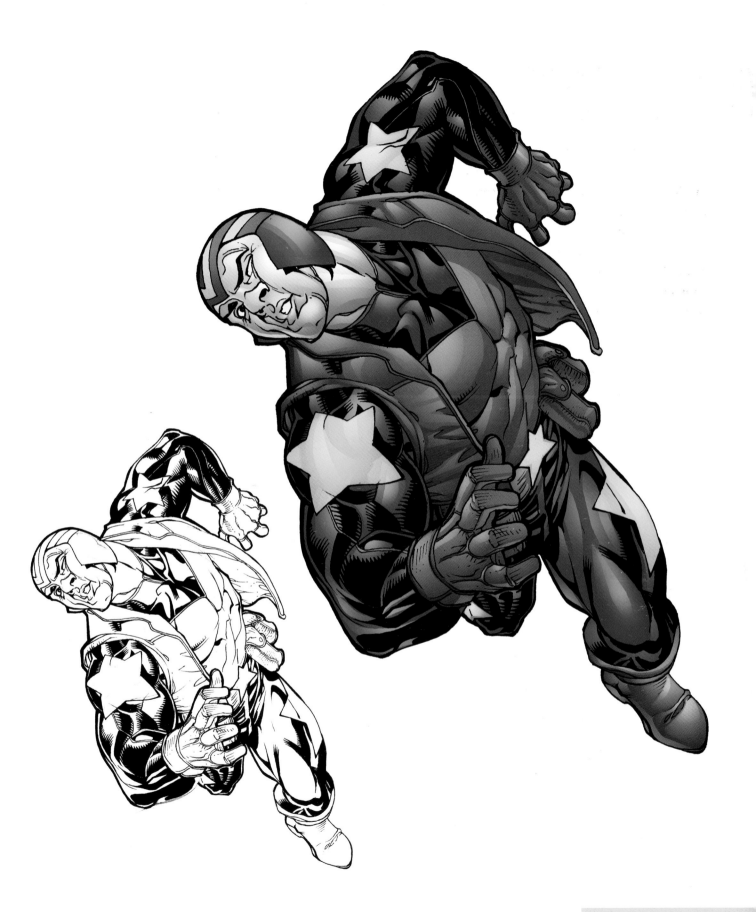

THE WEIGHT-BEARING LEG

So now that you're getting the hang of foreshortening, this is where the body dynamics come in. The body is a highly tuned performance machine, with all parts working together as a unit. It exerts force and reacts to stress. Pressure is exerted when a person stands, bends, leans, and balances. All of these dynamics occur smoothly as part of the pose. Highlighting and exaggerating these dynamics (often with the use of foreshortening) is what makes comic book poses powerful. The principles by which the body moves to create dramatic posing are referred to as *body dynamics*, and just like foreshortening, they're essential tools in your arsenal of comic book techniques.

To begin, symmetrical poses—those in which both legs are positioned in the exact same way—are generally not dynamic. Of course, there are exceptions to every rule; however, most of the time, you'll find it visually more interesting to avoid this type of symmetry. The easiest way is to have one leg bear the majority of the weight. Rarely do people stand with precisely equal weight on both feet. So when drawing a standing pose, decide which leg should bear the most weight, and then exaggerate that gesture. Use that leg as if it's a pillar or column. Usually, the *weight-bearing leg* is the one *directly under the body*. The relaxed leg is positioned away from the body.

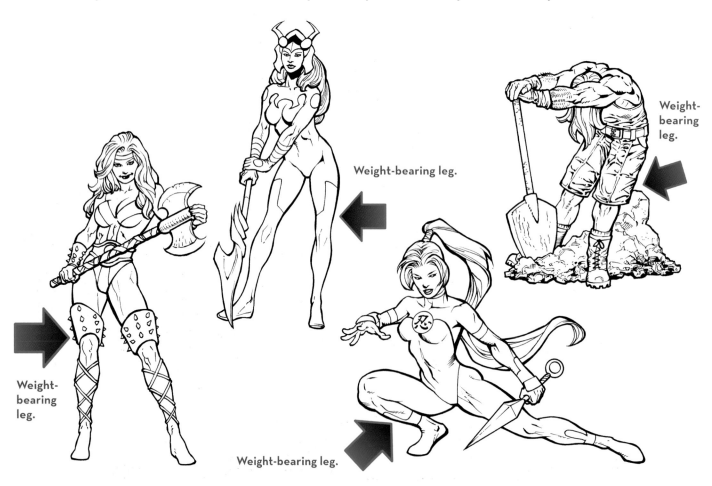

Weight-bearing leg.

Weight-bearing leg.

Weight-bearing leg.

Weight-bearing leg.

The push-off force starts at the foot and carries right through to the fist.

THE PUSH-OFF LEG

In most action poses, one leg acts as either a shock absorber to absorb energy or a piston to propel the character forward (or backward). This is the *push-off* leg. Sometimes, both legs can function as the push-off force in a pose. By using the legs as the source of power, you create a driving force that sends energy up from the foot all the way through the arms and shoulders.

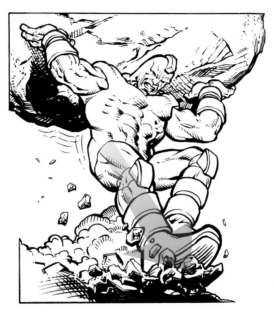

Here, one leg acts as a shock absorber—a push-off leg in reverse.

One leg pushes this figure off the ground with enough force to smash solid matter.

Two legs push off (or brace) against the opposing force that is attached to the other end of that rope.

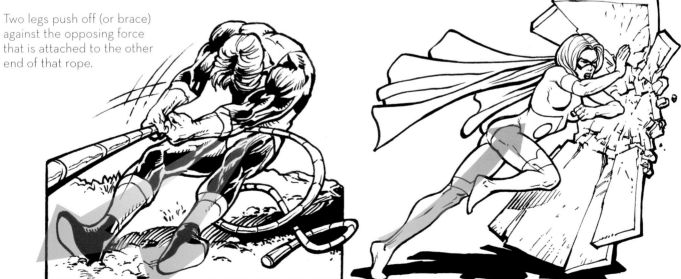

BALANCE AND POSING

Where is the center of balance in a pose? It's on the ground in a spot directly even with the neck. That doesn't mean that one, or both, of the feet must always be placed at that exact spot. For example, in these illustrations the head is leading the feet. In the lower right example, the knee becomes the center of balance, as it is now directly under the neck.

When a character is in a neutral position, neither leaning forward nor back, the body mass is evenly distributed in front and behind the point of balance; hence, there is little momentum. However, when a character is involved in extreme action, the body leans far in front of (or way behind) the point of balance. In other words, extreme poses should look off balance. Why is that? Because characters moving drastically are, quite literally, in the process of *falling* and must quickly take another step or they'll crash! Therefore, the more extreme the pose, the more likely that the feet will not be positioned directly under the neck.

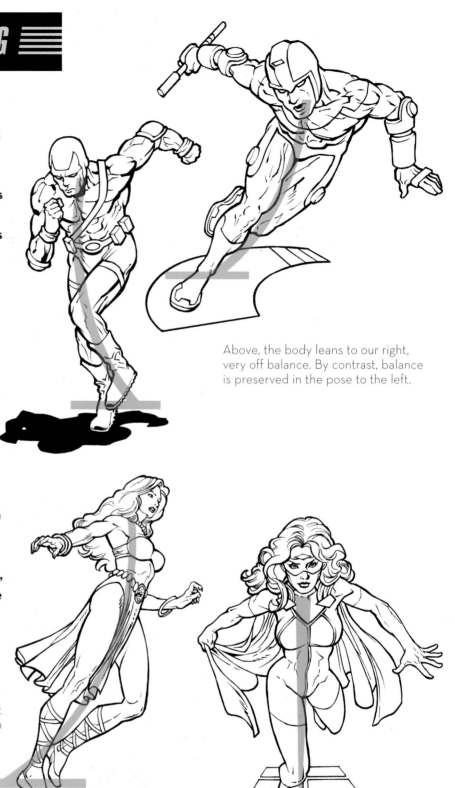

Above, the body leans to our right, very off balance. By contrast, balance is preserved in the pose to the left.

These poses show a character moving forward, past the point of balance, in a walking motion and taking off in flight.

Pulling Up

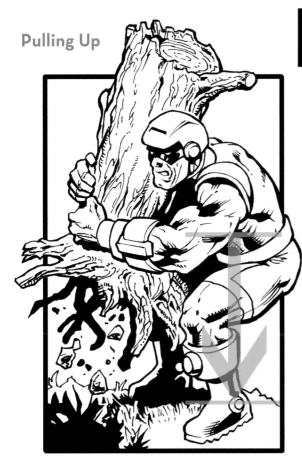

THE CENTER OF GRAVITY

In any given pose, the center of gravity is the center of mass, or the spot on the body where the entire weight is considered as concentrated—meaning that if supported at this spot, the body would remain balanced.

The more power your character exerts in a pose, the lower the center of gravity will be. That's why when you see a character throwing a real haymaker, the legs are spread wide apart (lowering the center of gravity). The part of the body that gets lowered when reaching for extra power is the hip area. Bring the hips down closer to the ground for power-driving poses.

Throwing

Pushing Up

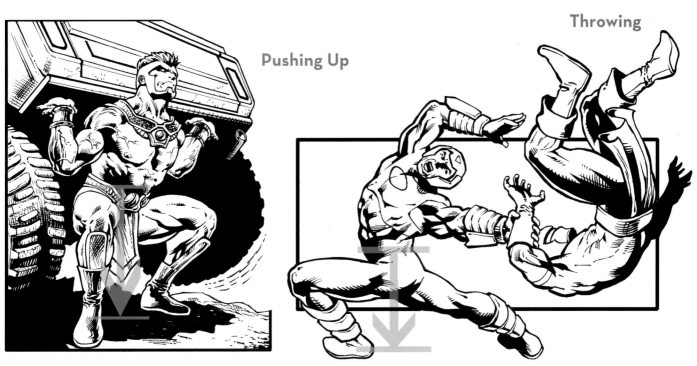

ACTION LINES

Every pose has a basic underlying thrust to it. This is called the *action line* and is especially apparent on *action poses*. This line is loosely sketched in as a guideline at the beginning of a drawing. By creating a line for the action to follow, you streamline your pose and simplify (and clarify) the direction of the thrust. Don't overcomplicate the action line: It should always be basic, never having more than one or two angles to it. Many different poses can be built on the same action line.

The action line travels down before sweeping up, all in a leftward motion.

The action line moves to the right in an upward direction.

The action line travels up and to the left before angling to the right for a hurdle position.

The action line travels up to the right before shifting back a little into a more straight-upward direction.

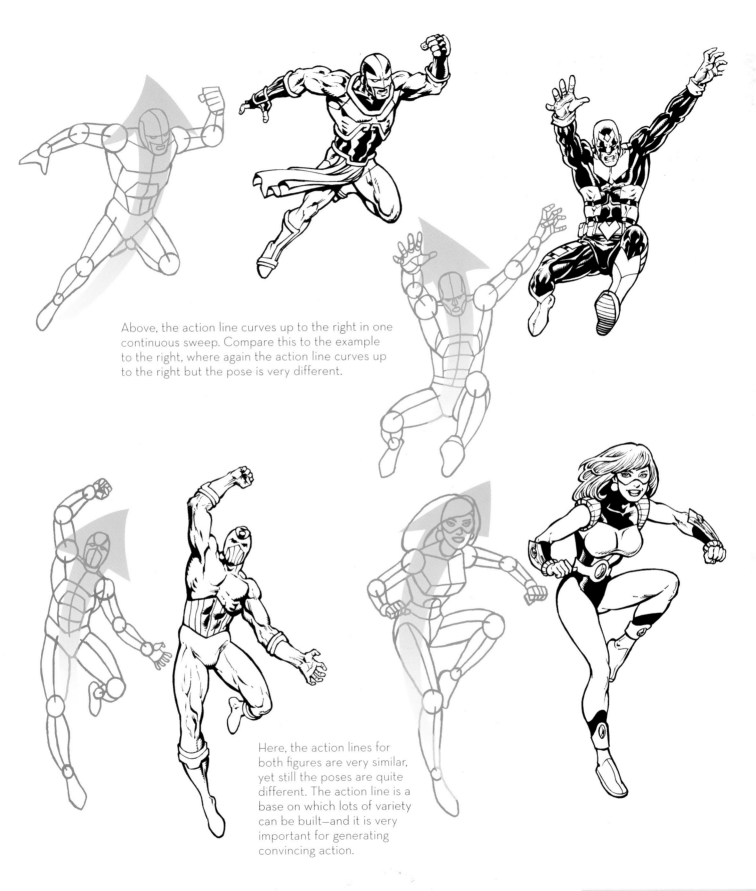

Above, the action line curves up to the right in one continuous sweep. Compare this to the example to the right, where again the action line curves up to the right but the pose is very different.

Here, the action lines for both figures are very similar, yet still the poses are quite different. The action line is a base on which lots of variety can be built—and it is very important for generating convincing action.

SHOULDER AND HIP DYNAMICS

Here's a technique you'll want to use often. It brings poses to life. When you initially sketch the figure, use one horizontal bar to indicate the line of the shoulders and another to indicate the line of the hips. Draw these two planes so that they're *not* parallel to each other. That's right, we want to avoid symmetry in most action poses. Therefore, the shoulder and hip on one side of the body should compress toward each other (appearing to squeeze together), while the shoulder and hip on the other side of the body should appear to stretch away from each other (lengthening that side of the figure). This stretching and pulling of the torso is quite dramatic. The reader feels its effect. But the beginning artist who hasn't mastered this technique isn't aware of what's making the pose so dynamic. Now you know. Keep this technique in your repertoire. It can turn an ordinary pose into a powerful one.

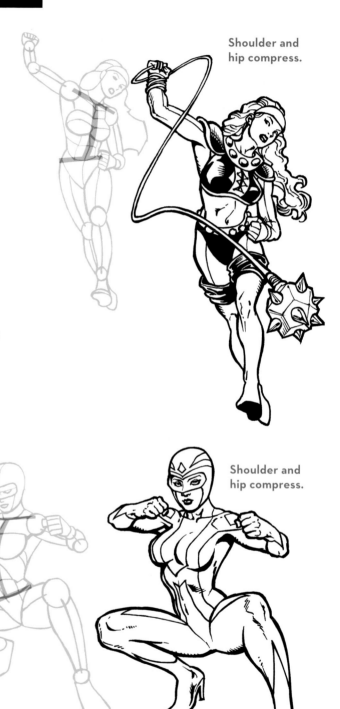

Shoulder and hip compress.

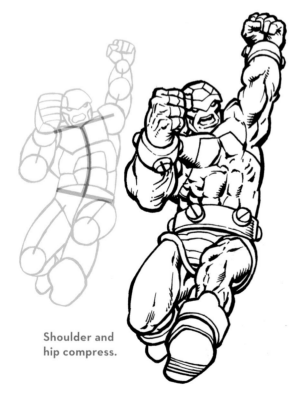

Shoulder and hip compress.

Shoulder and hip compress.

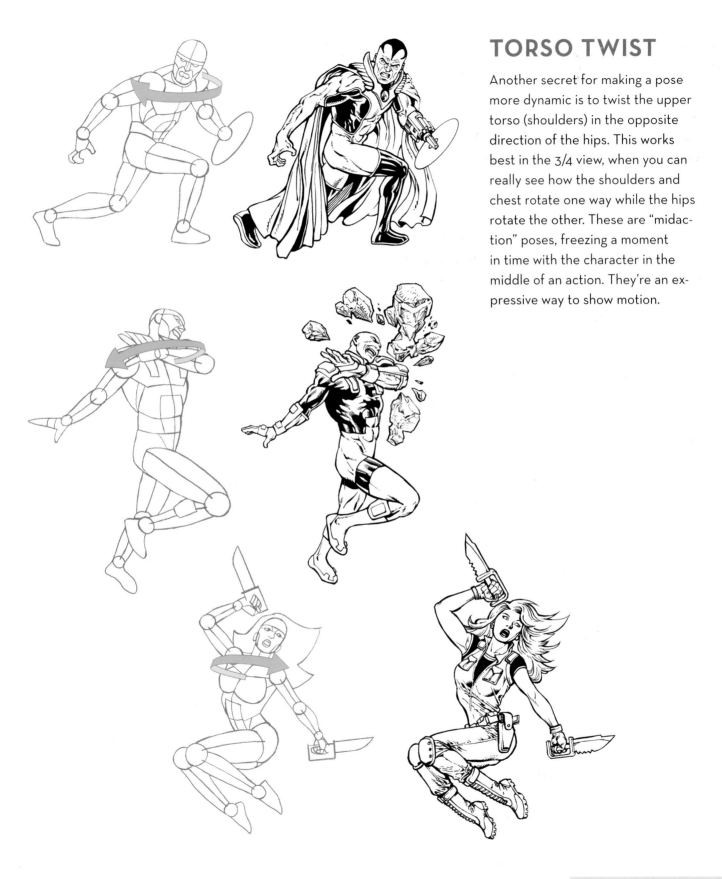

TORSO TWIST

Another secret for making a pose more dynamic is to twist the upper torso (shoulders) in the opposite direction of the hips. This works best in the 3/4 view, when you can really see how the shoulders and chest rotate one way while the hips rotate the other. These are "midaction" poses, freezing a moment in time with the character in the middle of an action. They're an expressive way to show motion.

CHAPTER **4**

The
GOOD GUYS

Superheroes in comics have got their problems. Superpowers aren't just a gift; they're also a curse. They make you different, an outsider. And you've got to continually restrain yourself from using those powers when tempted—for example, when a cabbie cuts you off in traffic. Although I personally think an exception could be made in that case.

Superheroes also suffer from poor day-job performance, due to late nights patrolling the city and nabbing crooks and thieves. Plus, the girl he loves doesn't have a clue who he really is. Which world does he belong to? Hers or the grit and grime of the streets he protects? These guys are also prone to bouts of despair, which gives comics gravitas. They usually win in the end, but these heroes also suffer their share of defeats and setbacks along the way—otherwise, where would the suspense come from? This tests their mettle. And a superhero is nothing if not single-minded in his desire to avenge himself.

You'll want to try this pose. It's a fan favorite. It shows our hero watching over the city, alone. Draw him broad on top, arms at the ready, with feet wide apart (about shoulder width). He's drawn at a 3/4 view, rather than straight on in the front view, because the angle makes it seem as though he's looking off into the distance.

The line of the spine indicates, roughly, the center of the body here. Small dots mark where the main joints will be. What you draw at this stage should be basic. But note that the overall attitude or gesture of the pose is there from the start.

To give the body a sense of form and three-dimensionality, map out the main limbs using cylinders.

Note that the use of a center line helps the artist define and position the torso's musculature, since the muscles (especially the pecs and abs) divide at the middle. Unlike the previous steps, this one features the center line of the torso (not the spine).

Now that the outline is locked in place, begin to suggest the major muscle groups.

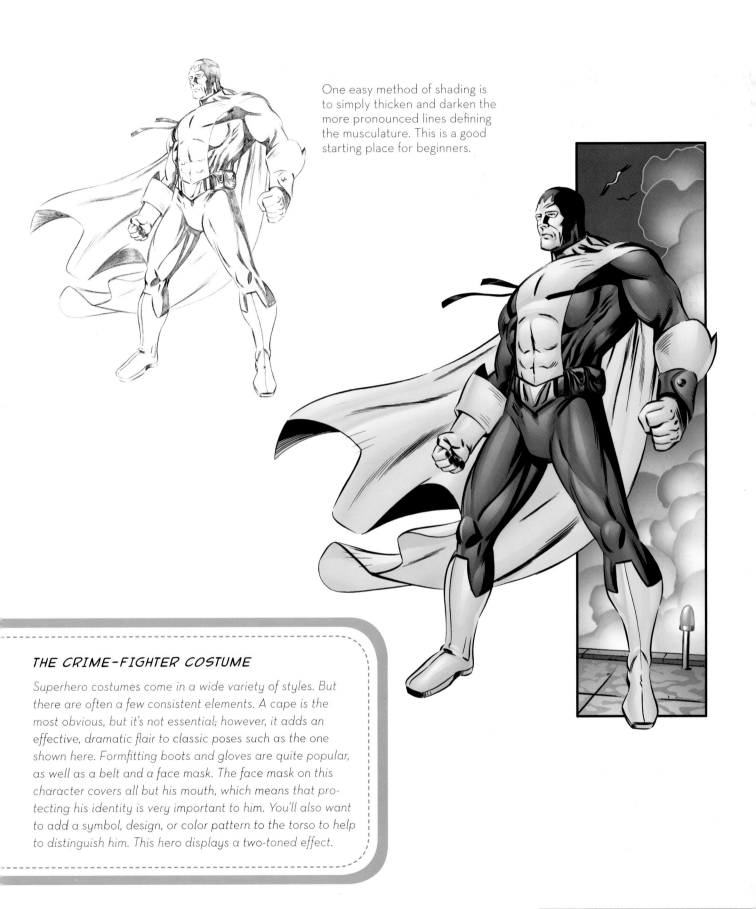

One easy method of shading is to simply thicken and darken the more pronounced lines defining the musculature. This is a good starting place for beginners.

THE CRIME-FIGHTER COSTUME

Superhero costumes come in a wide variety of styles. But there are often a few consistent elements. A cape is the most obvious, but it's not essential; however, it adds an effective, dramatic flair to classic poses such as the one shown here. Formfitting boots and gloves are quite popular, as well as a belt and a face mask. The face mask on this character covers all but his mouth, which means that protecting his identity is very important to him. You'll also want to add a symbol, design, or color pattern to the torso to help to distinguish him. This hero displays a two-toned effect.

THE CRIME-FIGHTER IN ACTION

This guy's such a classic that he warrants another look. He doesn't want to actually hurt this miscreant; he just wants to shake some information out of him, but all he's getting is a song and dance. This profile shows off the character's impressive girth. Note the barrel-like chest, basketball-sized shoulders, and the way the neck tilts forward in an aggressive posture. When the arms pull in like this, the *biceps* flex. If the arms were to push away, and lock at the elbows, the *triceps* would flex.

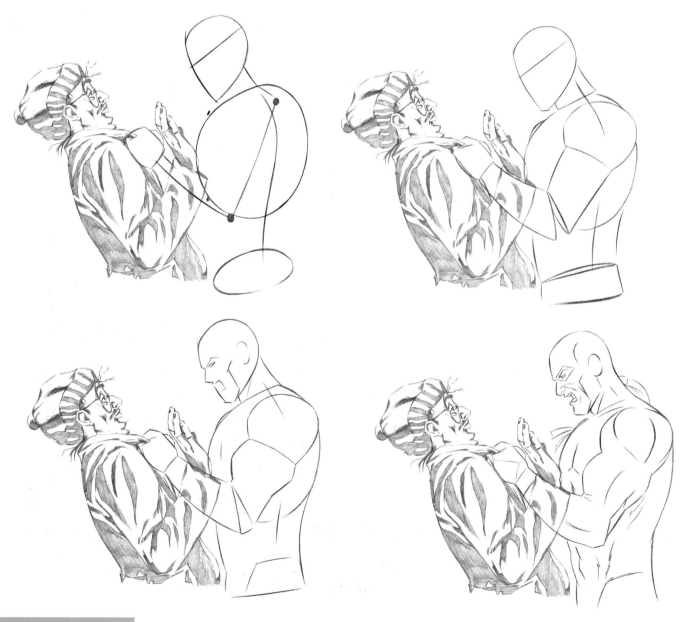

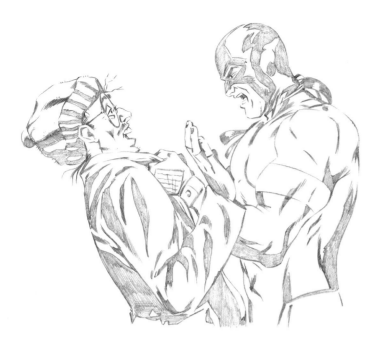

THE COSTUMED CRIME-FIGHTER

The costumed crime-fighter is the most popular type of comic book character. His opponents run the gamut from two-bit criminals to superpowered criminal masterminds. Often, he works outside the law in order to maintain it; the city may be filled with corrupt cops, so he can't take a chance on trusting them. Besides, he works alone. Only a select few can call him their friend.

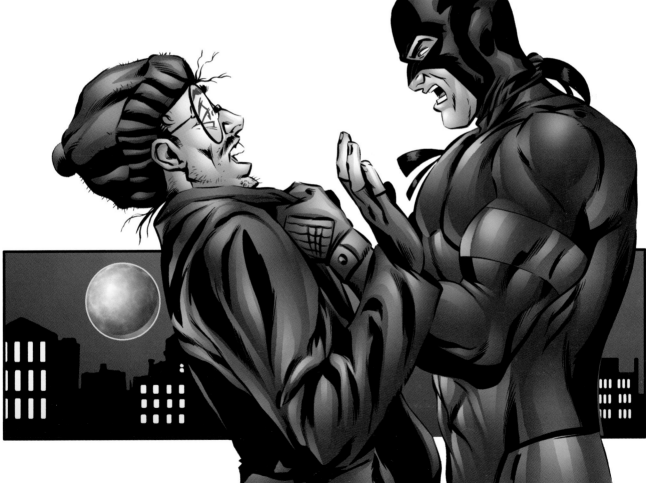

Flying poses almost always use a great deal of fore-shortening (which compresses the body). Although it may appear somewhat challenging to incorporate this effect, once you get used to it, drawing a flying character with foreshortening will actually feel easier than drawing one without it. That's because foreshortening eliminates parts of the body (the lower legs, in this instance) that you would otherwise have to draw. Plus, it forces you to simplify things in order to keep them in perspective; in this drawing, for example, the chest and midsection are drawn as one combined shape. And, you'd have to work a lot harder to create a dramatic pose if you drew this guy flying in side view, because without foreshortening it would look very flat.

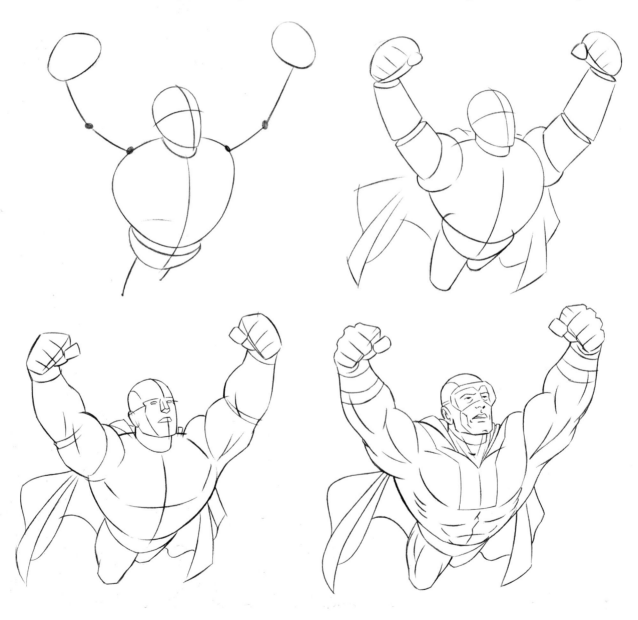

THE APPEAL OF FLYING

Everyone has a special power. But this one is particularly appealing, because every kid has had the fantasy of flying. And it's also an important skill, since flying can help a superhero respond to a distress signal sooner. Plus, in addition to striking those flashy flying poses, he can also fight in midair, which makes for some very cool scenes. This is especially true when he's battling a humongous opponent, like a giant monster, and he has to use speed, rather than strength, in order to win.

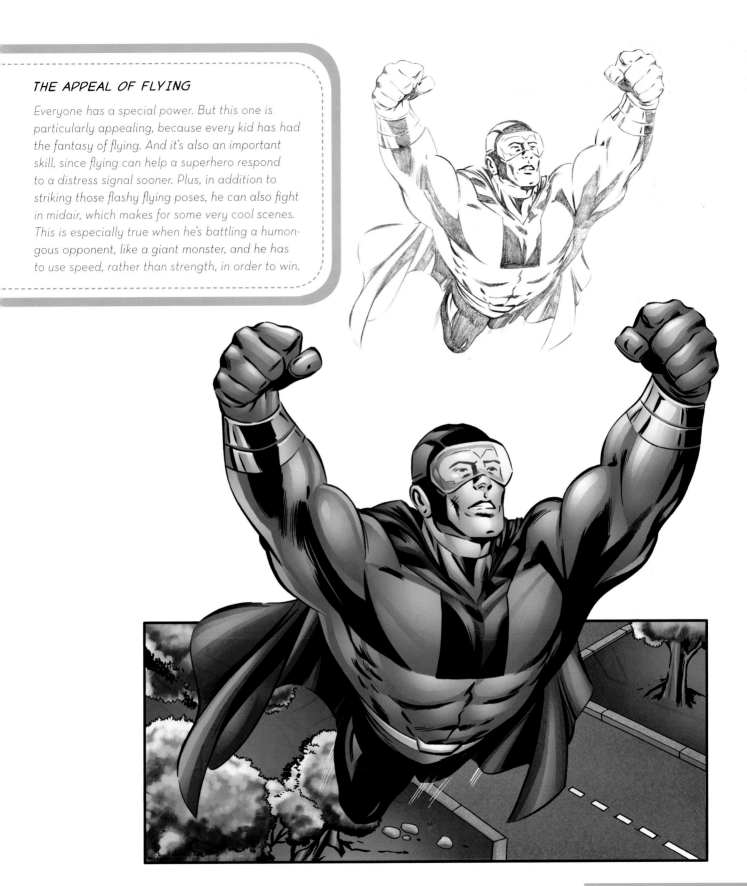

CRIME-FIGHTER GAL

What she lacks in brute strength, the female crime-fighter makes up for in guile and feistiness. Often she's jealous of the superhero's fame and accomplishments, and takes it as a personal challenge to one-up him—even if that means making him her enemy. It would be a mistake to underestimate her. She may also have other superpowers in addition to flight or hidden weapons.

Note that this is an important pose to add to your repertoire: landing on a city rooftop. Landing on a crowded sidewalk is too conspicuous, and landing in the middle of traffic is too dangerous. Besides, from the rooftop, your character can survey the entire city below. To add to the feeling of action, one foot makes contact with the ground while the other is still airborne, about to touch down.

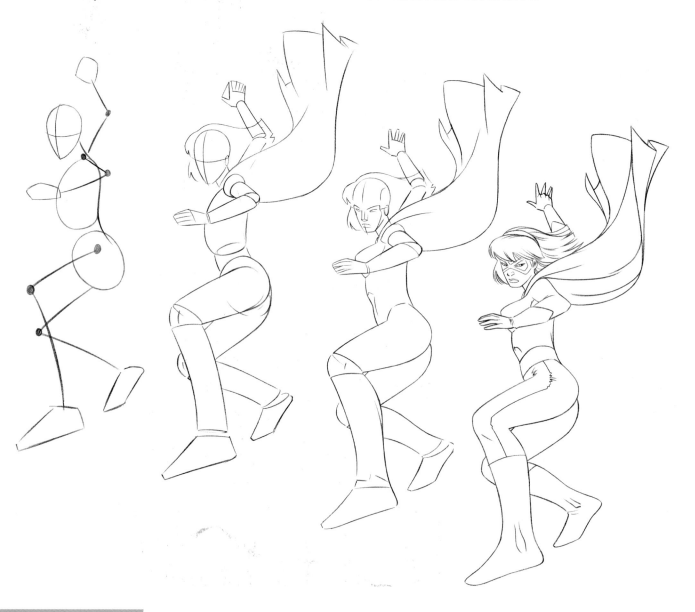

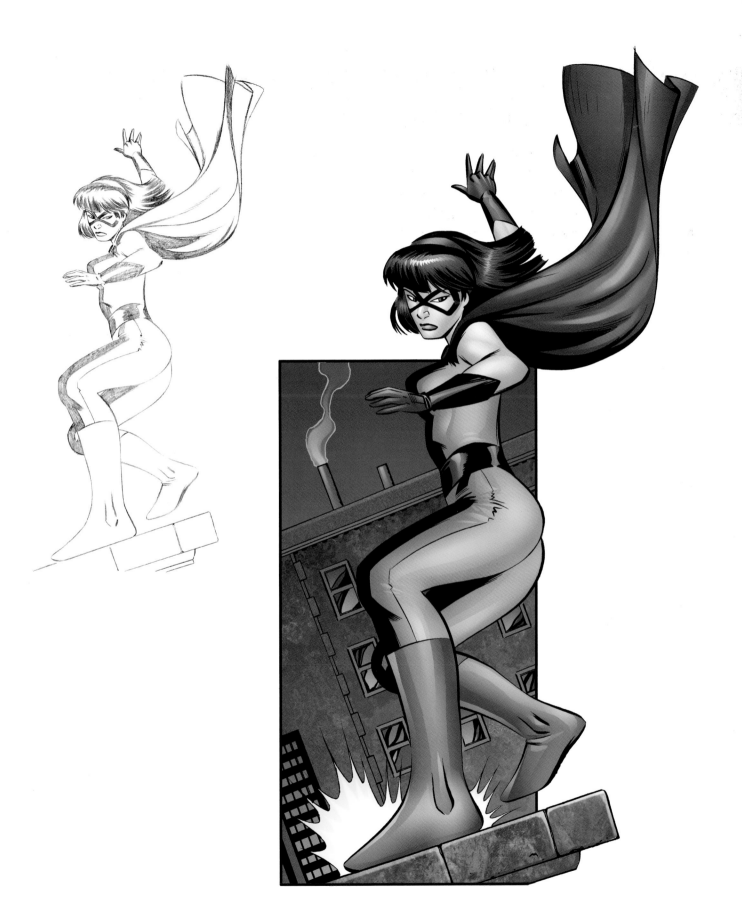

Every team of superheroes needs a guy with muscle to break things and toss a few cars at the bad guys. That's where the big buddy–type character comes in. He's affable enough, like a gentle giant. But you don't want to mess with his friends. His is the brute type of physique: massive upper body, huge hands, and a small head. The shoulders are drawn as wide as possible, and the quadriceps are the shape and size of watermelons. The forward-reaching arm and the bent leg are severely foreshortened (compressed). To render something like this, layer the sections of the forward-reaching arm (hand, forearm, upper arm, shoulder), and overlap them to make them appear to recede. For the leg, define the kneecap so that it adds definition to the massive thigh.

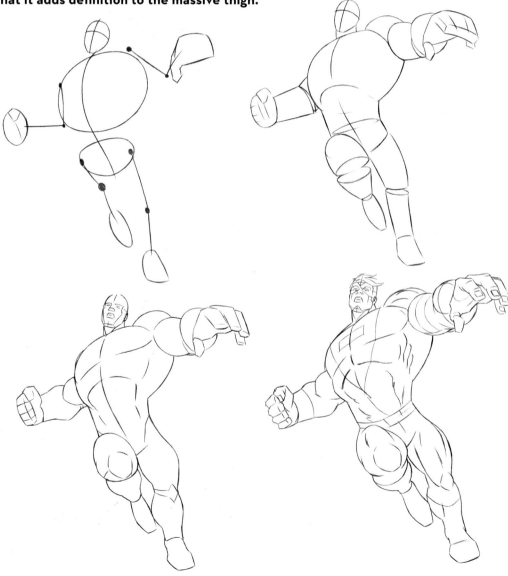

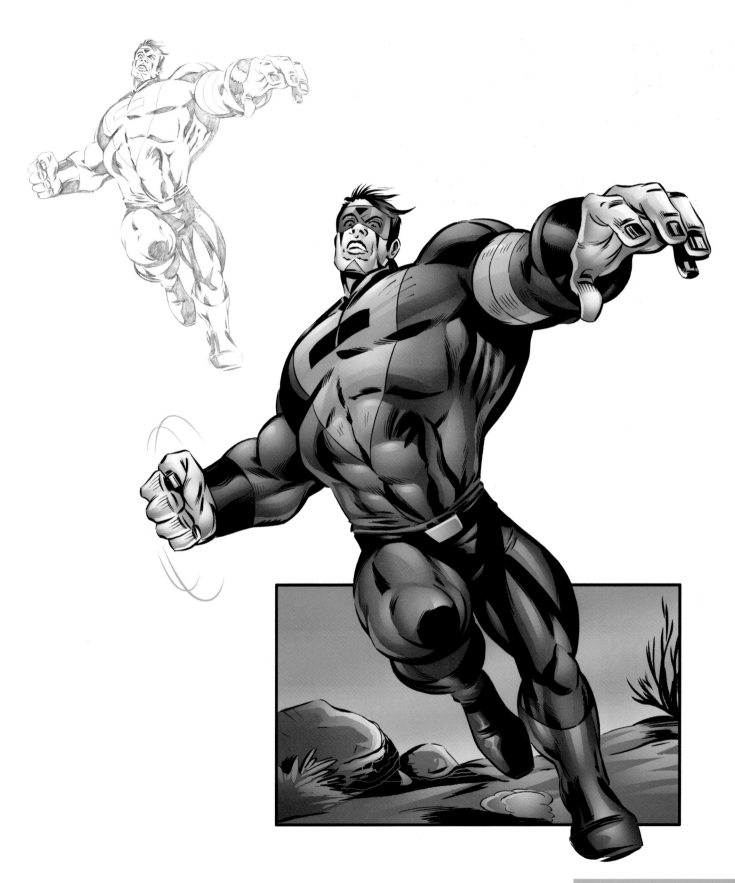

SUPPORTING CHARACTERS

The world of comic book characters isn't filled solely with superheroes and supervillains. There are lots of other important characters who round out the superhero's world. These supporting characters are normal people (imagine that!) living, working, loving, and earning a living in the big bad city. They are the potential victims of the supervillains and the people our hero must rescue—even if some of them rub him the wrong way.

FEMALE REPORTER

Brashly assertive, the female reporter doesn't idolize the superhero because she's only interested in getting a good story out of him. Of course, she's also an obvious candidate for the hero's love interest. Her type of character makes a good story arc. By that I mean that her character starts off at one place and ends up at a very different one. For example, she starts out tough and independent but, through her adventures with the superhero, finds herself willing to let herself need other people and, perhaps, even fall in love. For her props, give her a microphone, a clipboard, or an attaché case.

 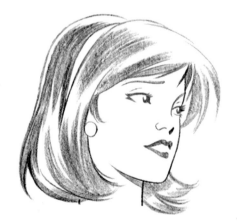 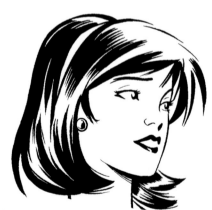

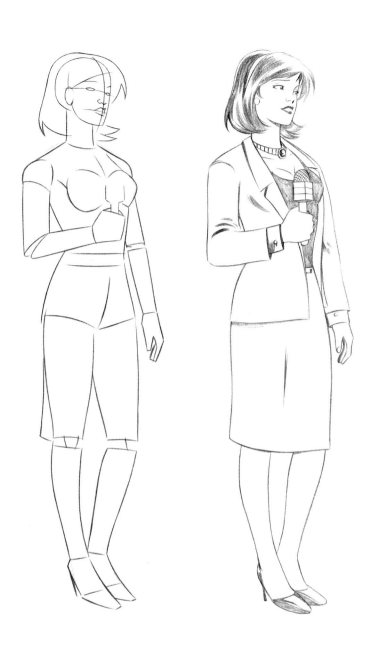
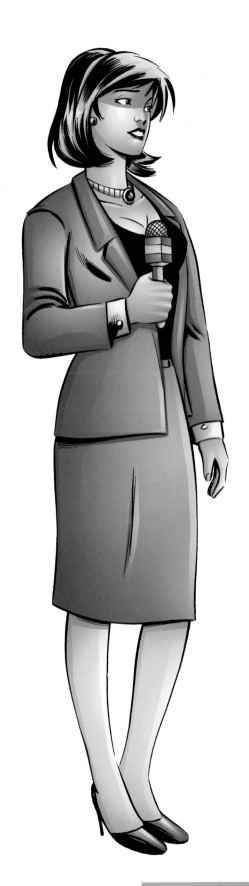

TABLOID PUBLISHER

His job is to say no. No to a raise. No to a sick day. The tabloid publisher is around fifty years old, a chain-smoker, and always worried about making deadlines and his mortgage. He's a type A personality, mainly because nothing comes before the letter A. Not the snappiest dresser in the Western Hemisphere, he nonetheless knows enough to buy a suit and tie—and not to wear plaid. Give him a gruff expression.

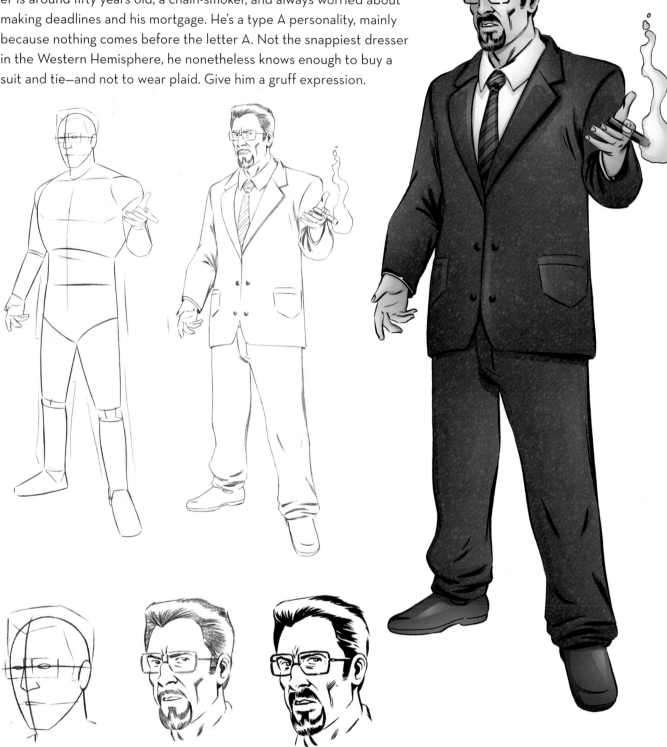

PAPARAZZO

You've gotta have someone who everyone hates to be the humorous thorn in the side of the superhero. And since lawyers aren't that interesting to draw, we'll go with the paparazzi. A paparazzo goes nowhere without his photographic equipment. This poses a danger to the superhero, who must guard his identity from the prying paparazzi eyes—and ubiquitous camera lenses. Draw this character in casual clothing, with lots of bags filled with gear.

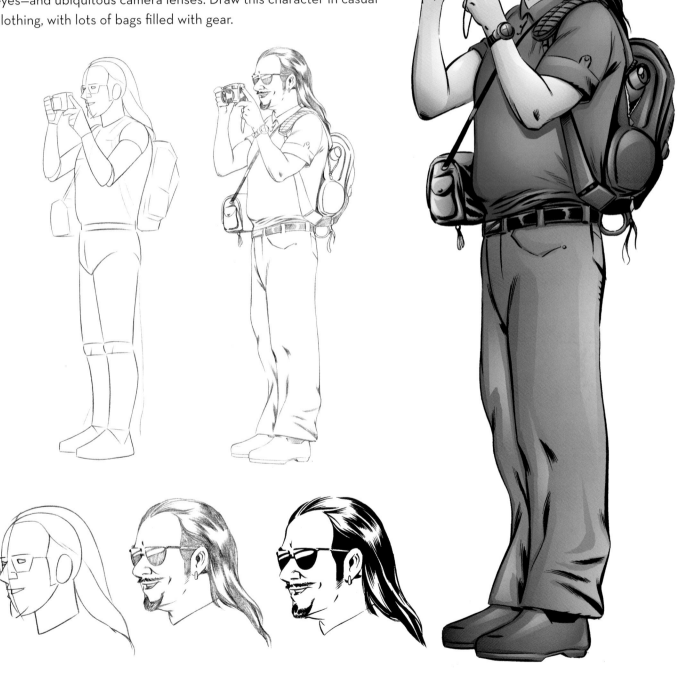

MISCREANTS,

Mutants
& Monsters

You've heard that in everyone there's a little good, deep down inside, yes? No. Not these guys. You can't drill that far. Bad guys have flair and style. Some of them even have superpowers, many of which were acquired by means of radiation, toxic waste exposure, or other environmental factors, rather than being innate. In other instances, they've built contraptions to give them special abilities. But sometimes, they're just amoral, especially the women, who have "come hither" eyes but deadly intentions—and are also, by the way, heavily armed. Bad guys can come in all shapes and sizes, but the one thing they have in common is that they make a splashy appearance and add a dark luster whenever they enter a scene.

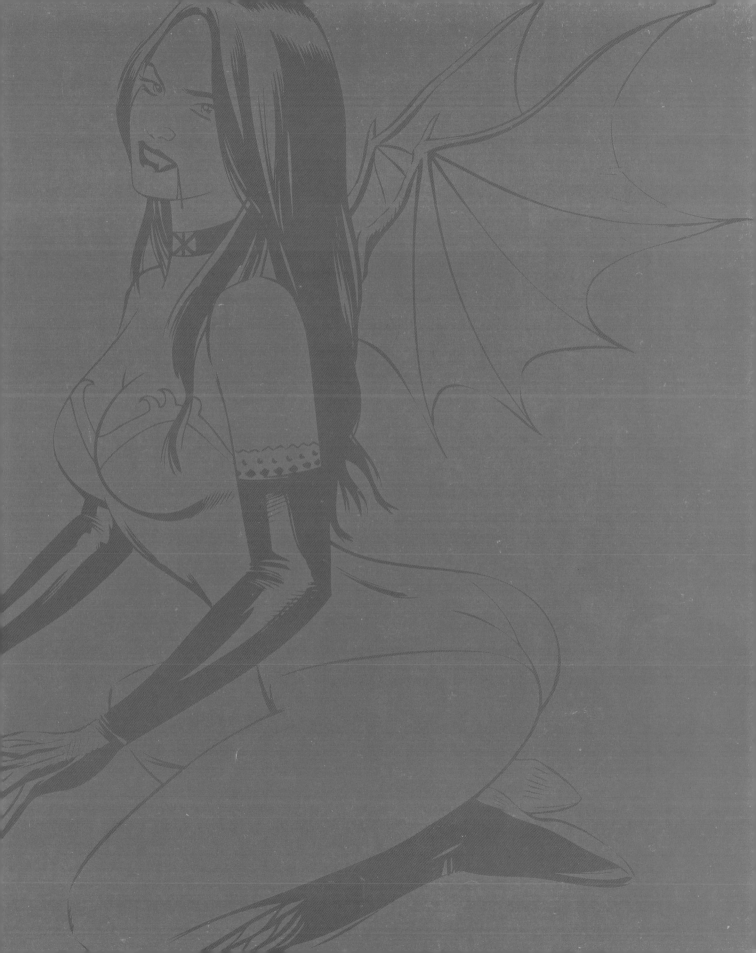

Mecha is a comic book term for "mechanical." Lots of bad guys are inventors. And rather than trying to invent a cheap, clean substitute for oil, they're generally working on mechanical devices that will help them bring the city to its knees. Hey, you can't fault them for a lack of ambition!

That weaponized uniform packs a wallop. The cannons mounted on his shoulders can fire anything you want: lasers, fire, ice, or even an energy beam that can drain the good guy's superstrength. You see, the bad guy already knows how strong the superhero is. He has done his homework. He has tested his equipment thoroughly and is ready for a spectacular confrontation, which he will win. Yes, he will beat the good guy—the first time out. (The good guy was unprepared for such a powerful enemy.) But you can only surprise a good guy once. The second time these two meet . . . well, let's just say that good guys excel at avenging their losses.

This bad guy doesn't possess a gigantic physique, as that would discount his need for so much equipment; rather, as an inventor, his build should be rather average and his weapon oversized. This bad guy has long hair and a beard—and that's no coincidence. He's the opposite of the clean-cut, all-American superhero.

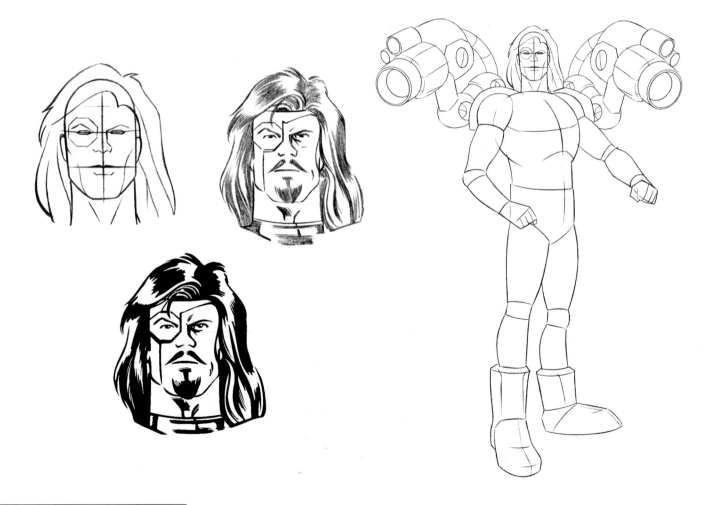

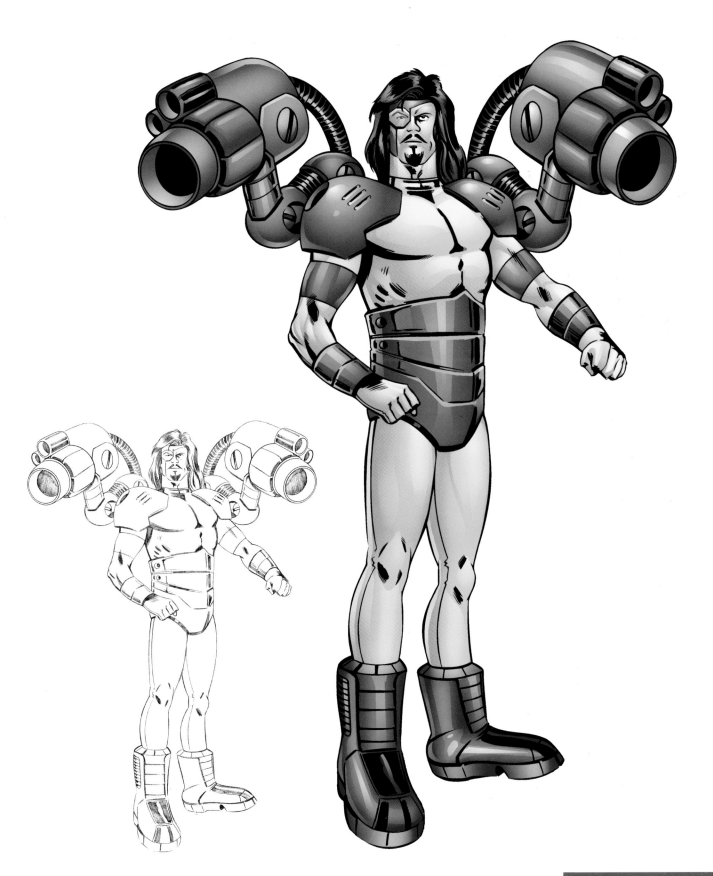

NATURAL-BORN KILLER

Talk about killer good looks. She's got 'em. The natural-born killer is more interesting if she's beautiful. When considering this kind of character, however, look past the obvious style, and remember that she still needs a solid foundation, like the one in the construction step here. Her classic, attractive proportions (long legs, curvy hips) are well fleshed in, and the thigh attaches deep into the pelvic area from the start.

Her hair is jet black, long, and straight. The lips are blackened. This is a severe look, and severe is good for female villains. In comics, long gloves are usually reserved for the wicked. So is a slit dress.

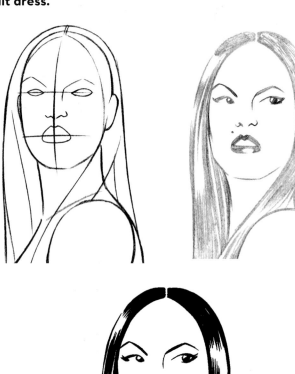

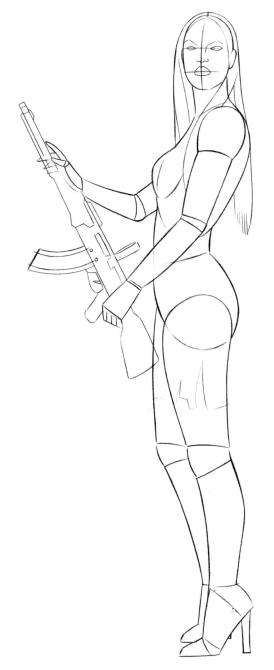

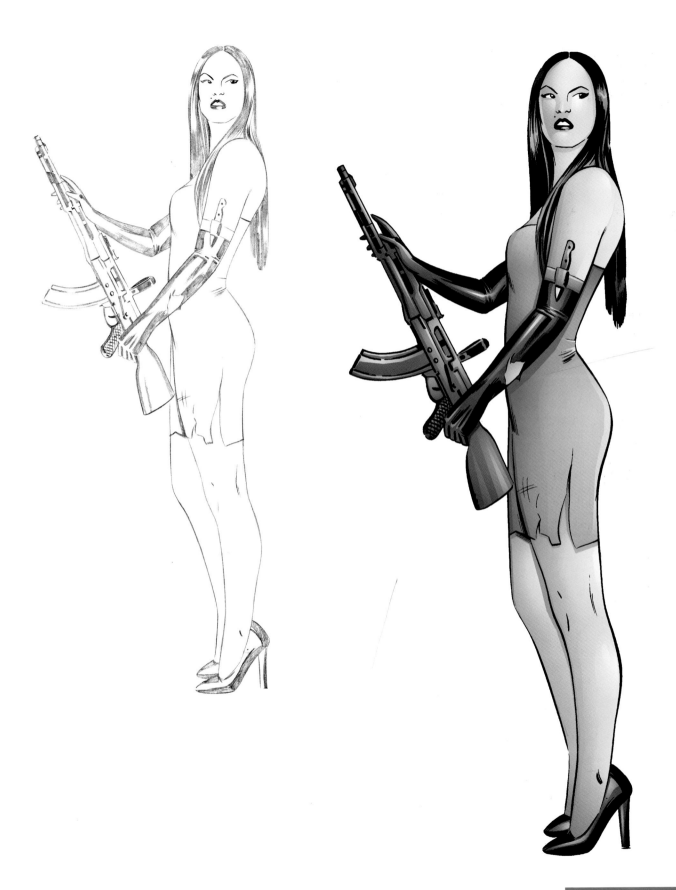

She has a bad attitude and lots of weapons. And who gave her those swords? I keep telling everyone to keep sharp things out of the hands of bad guys! This character commands an army of primitive females. She's not just a figurehead but is also a fighting character. She's the first into battle. When presented with prisoners, it is she who decides who lives, who dies, and whom she finds attractive. . . .

As a queen, she has to be more physically impressive than the average bad gal. So she has much longer, more heroic proportions. Note the extralong legs and smaller head relative to body size. The long, sinewy shape of the muscles keeps her looking feminine despite the added height; don't give her short, bulky, bodybuilder muscles.

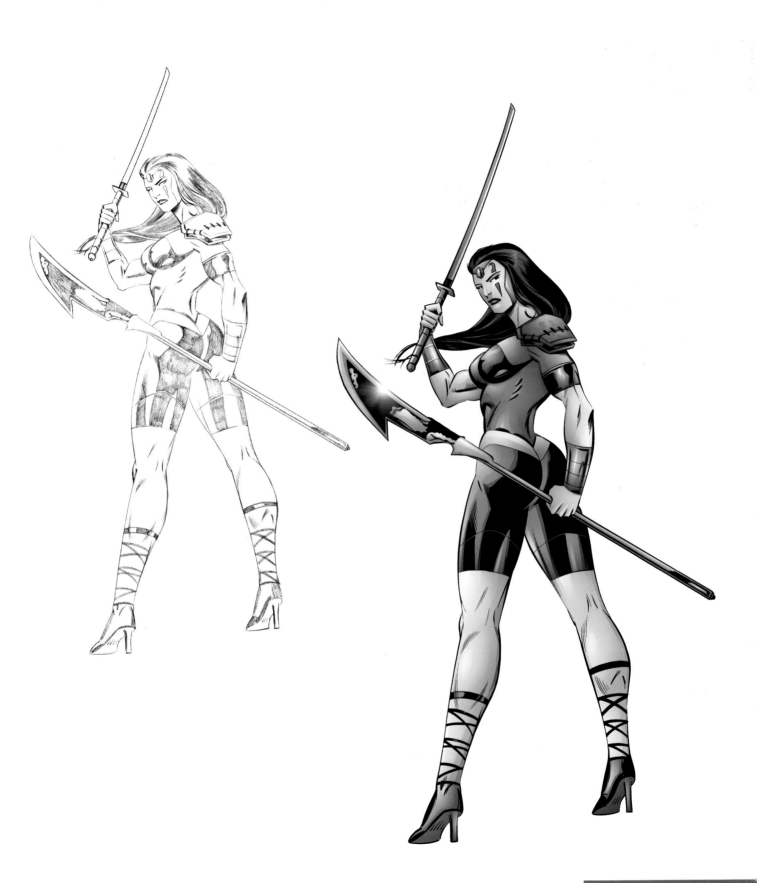

In comics, bad cops are really, really bad. Instead of stealing an occasional doughnut from the basket, they're out to make a killing, literally. Bad cops can be cyborgs, demons, mutants, or simply the criminally insane. Common to the horror genre, you've no doubt seen the living-skeleton-type character before, cast as the captain of a pirate ship. But he can also be used in combination with other standard characters to produce a deathly aura. In addition to a cop, the living skeleton can be the leader of an occult army; the head of an organized crime ring; a zombie; or an evil, superpowered, costumed character with a cape. It's hard to kill someone who's already dead, and the skeleton guy just keeps coming at you. Draw some rips and tears in the costume to reveal the bones underneath.

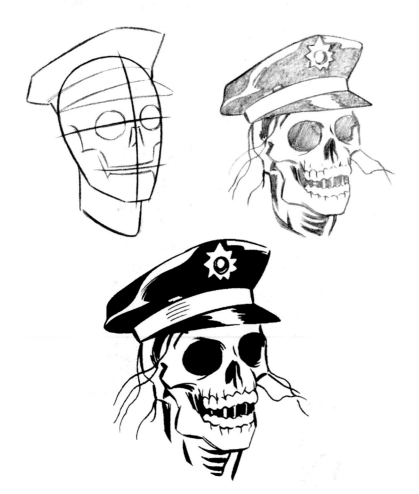

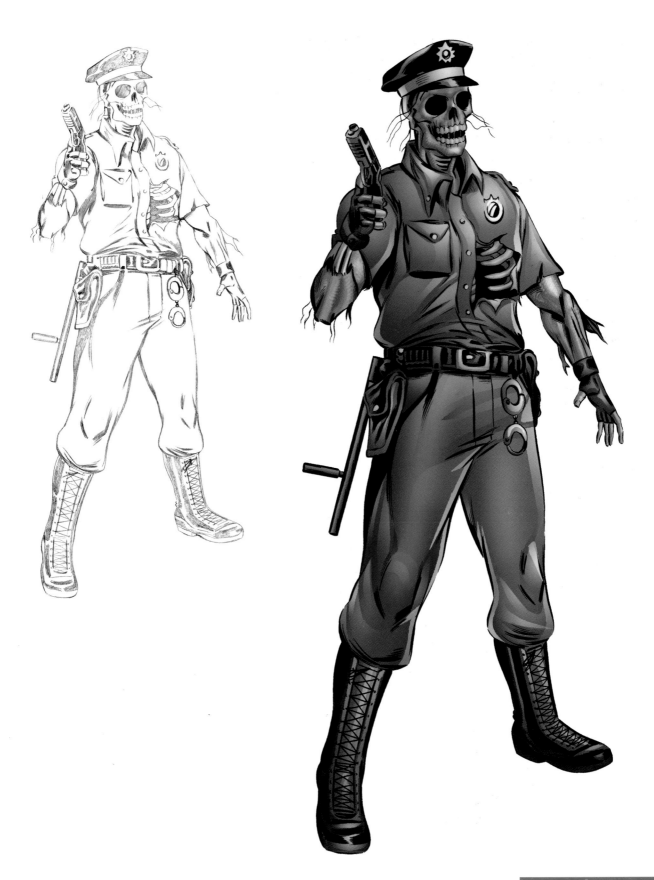

VAMPIRE CHICK

The underworld is filled with darkly charismatic characters. Among the most popular is the vampire, especially the female undead. She's both dangerous and seductive. She's a black widow, luring you with her drop-dead good looks and then taking her bite.

When drawing her, *choose a moment*. What do I mean by that? Draw her at a specific stage in the classic vampire attack. For example, some of those moments include her insane hunger, being seductive, delivering the death kiss, being sated immediately after feeding, and sleeping until the hunger awakens her once more.

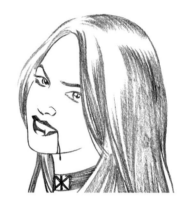

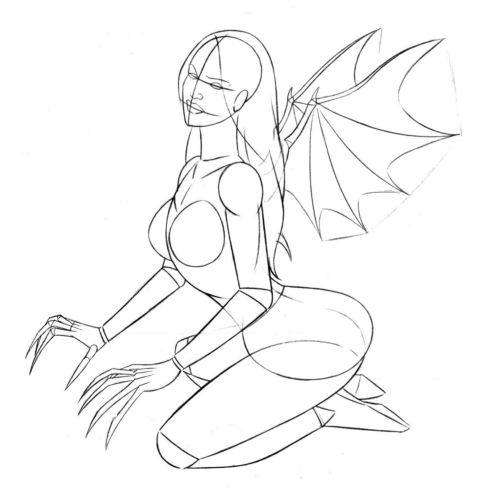

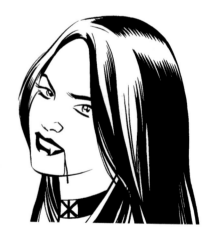

FANGS, WINGS & THINGS

That's what gives her the right look. The "things" can include a neck choker, amulets, long gloves, skull motifs, a staff, blackened fingernails, blackened lips, a devilish tiara (for vampire queens), and rings and arm and thigh bands with occult symbols on them.

Wings can be small and decorative, like these on the vampire chick, all the way up to massive and all-enveloping. The bigger they are, the more attention they attract to themselves and away from the character. Something to keep in mind.

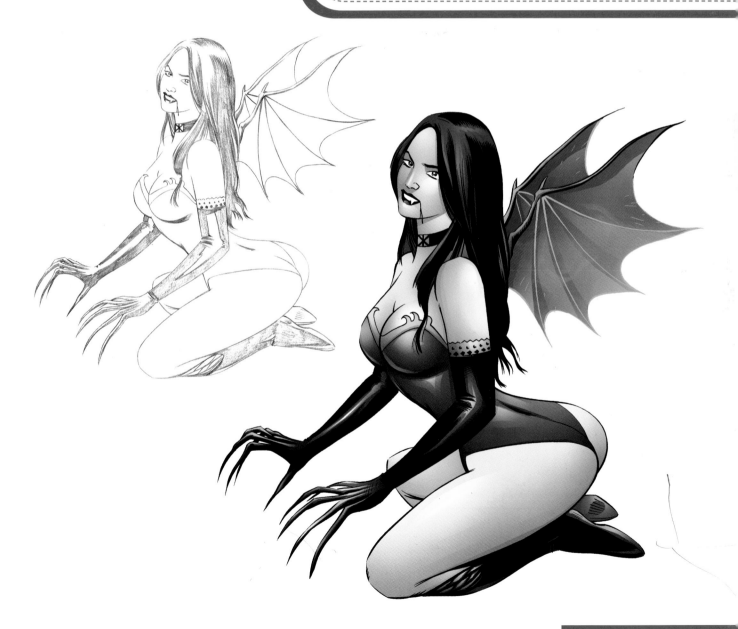

DEATH RAY

The character who possesses a death ray is a particularly dangerous and painful opponent for the hero. Death rays can emanate from many places on the character, including the eyes, the visor, the top of a helmet, the fingertips, the palms, the chest (if there's a special mecha attachment to the chest or a large crystal there), or a ring on the finger.

Death rays are dramatic because they kill s-l-o-w-l-y. They weaken the good guy so that the audience feels his pain and frustration as he is sapped of his life force. You can only fight off a death ray for so long before you begin to succumb. In order to win, the hero must either grab something to use as a shield (a manhole cover, perhaps) or find some way to reflect the beam back onto the bad guy, turning the tables on him.

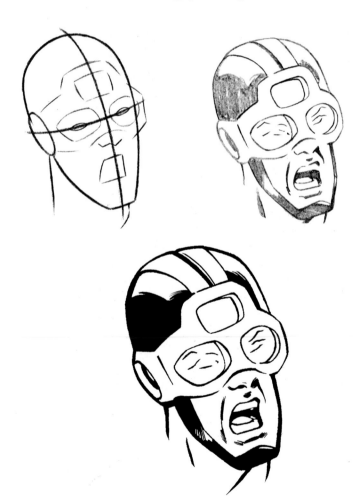

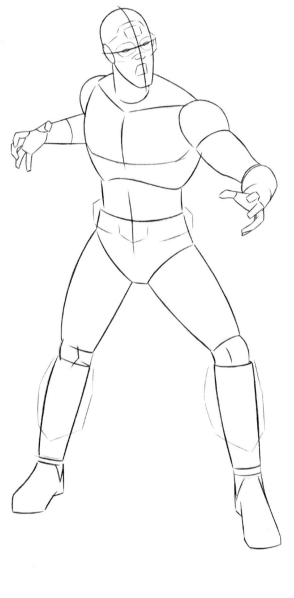

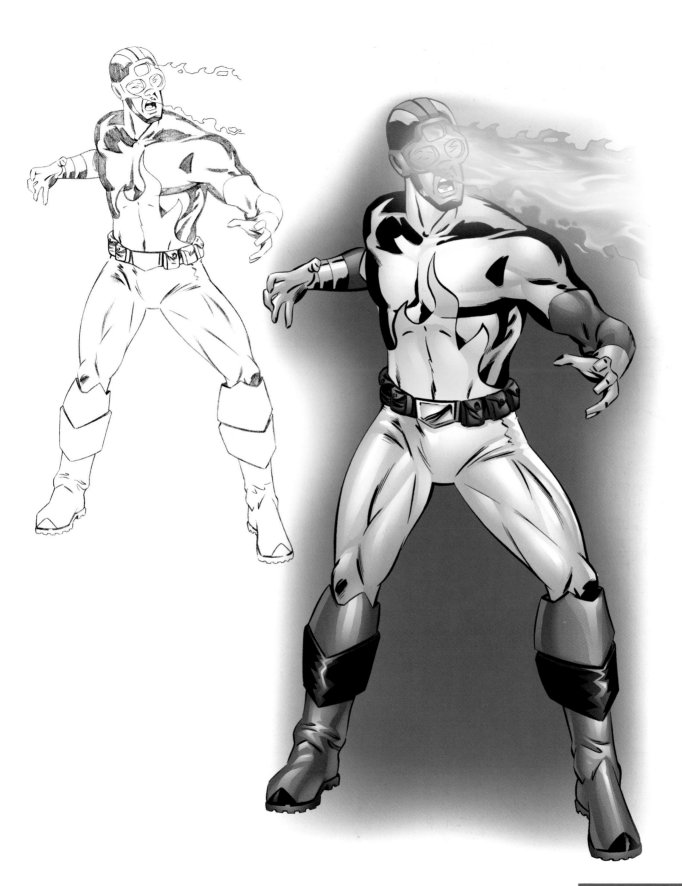

GIANT CLAMP

There's a long history in comics of characters using mechanical devices to enhance their strength. But the character is doubly dangerous when he's also a giant. Our superhero, small and helpless, is trapped in his viselike grip. This is a dramatic device and plays on your fears of being squeezed to death, which you probably got from your aunt Debbie.

With the "surround-helmet" and backpack, this mecha unit is a life-support system, which means it's vulnerable; there has to be a way of disabling it. But there's very little time before our hero gets pancaked. He can't get out, so what's he gonna do? If the hero can just use his eyebeams to fry one of the cables on the hydraulic system of the arm, the clamp will spring open.

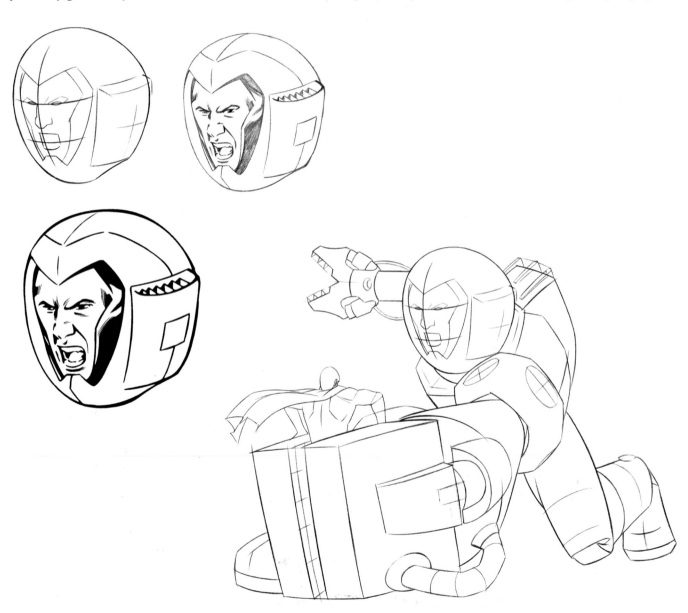

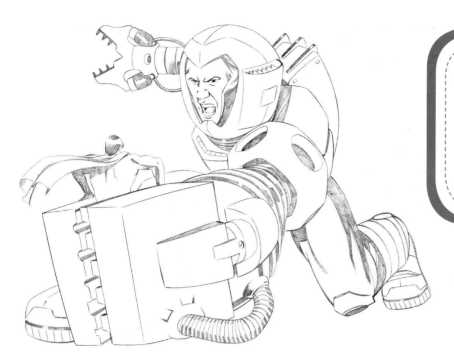

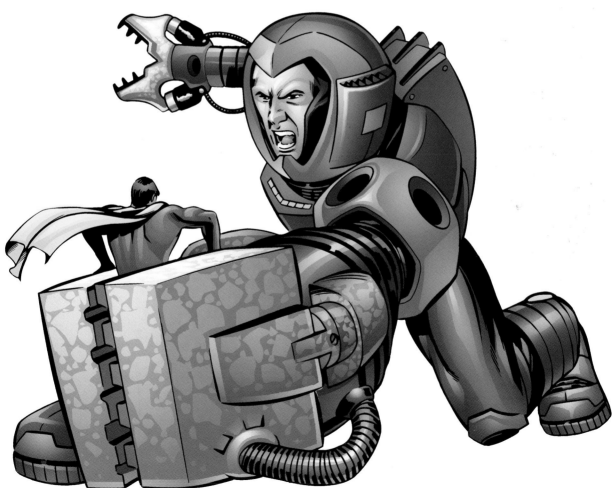

REPTILIAN ALIEN

Here's the classic approach to drawing the space alien bad gal: She's generally reptilian in appearance. Her face has a minimum of features set around humongous, almond-shaped eyes, which can glow and shoot beams. There's no nose or only the slightest indication of one. She's usually bald. The body is sexy, but it also has striations or scales, warts, fins, markings, or spiky protuberances that make you think twice about asking for a date. Often, she's shiny, with slick or slimy skin. She may also exude some sort of power; it can be a glow that surrounds her and kills or repels whatever touches it. Sometimes, these feminine figures have superstrength that can crush an enemy. Other times, they can emit a sticky substance from their fingertips or vanish when they concentrate.

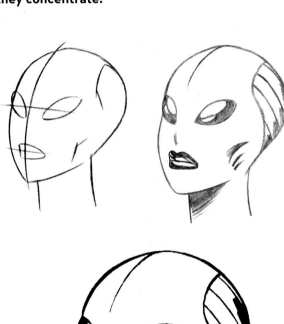

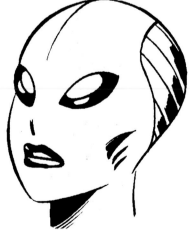

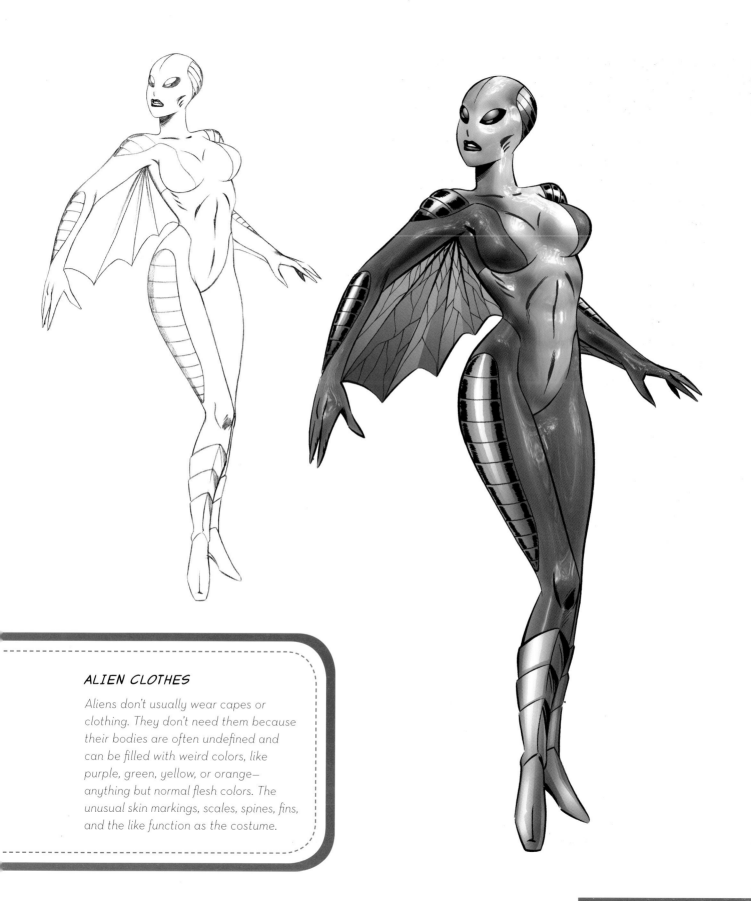

ALIEN CLOTHES

Aliens don't usually wear capes or clothing. They don't need them because their bodies are often undefined and can be filled with weird colors, like purple, green, yellow, or orange—anything but normal flesh colors. The unusual skin markings, scales, spines, fins, and the like function as the costume.

Hell hath no fury like a lizard mutant. These guys are ruthless gladiators, marauding primitive worlds in search of human slaves. Great subjects for the fantasy genre, the lizard mutant strikes fear into the hearts of readers because it's so ugly and alien looking. Which brings us to another genre, sci-fi. Often, lizard mutants are cast as commanders of enemy space vessels in sci-fi comics. They're the pirates of the galaxy, disabling other ships, boarding them, and taking human prisoners back to their home planet. Hey, good help is hard to find!

Make sure to give your lizard guy spiny protuberances on the neck and lots of warts on the face. The eye has a shine in it, but there are no whites of the eye in lizards; it's all one moist, black dot. Yes, he's quite the handsome fellow. And note the pouchlike skin flap just below the chin/neck area. Drape him in armor, which conveys his warrior status. Four fingers, instead of five, are used to make him look other than human. Some artists will use only three fingers (two plus the thumb), and I've even seen an instance where only one (plus the thumb) was used. I'm still creeped out by it!

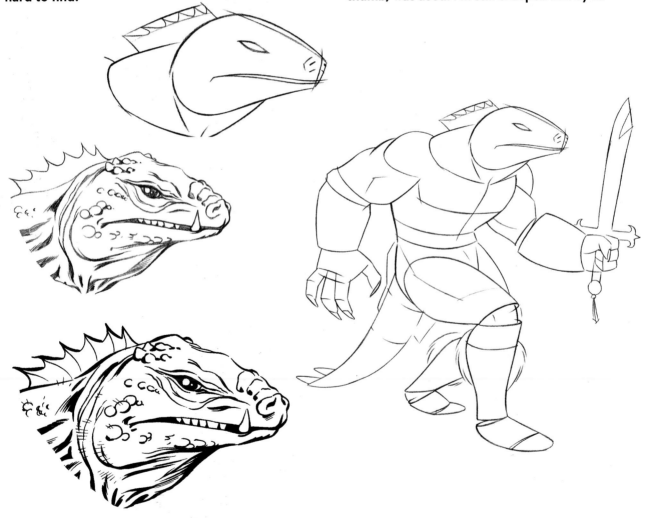

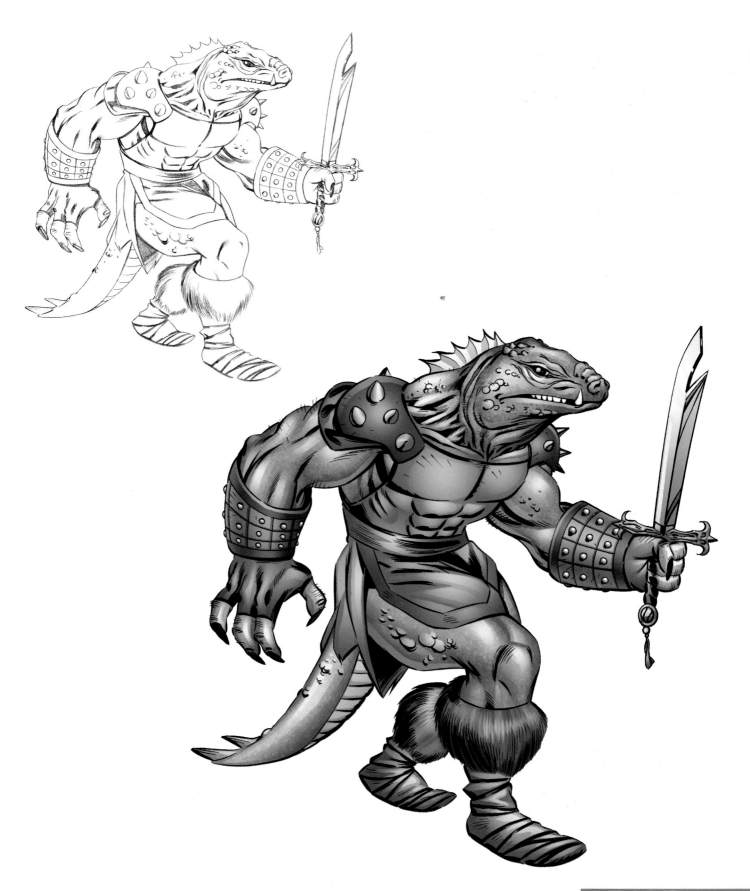

Anthros are animal-human combos. Like animals, they're wild, fierce, and unpredictable. In fact, their mannerisms should mimic the animal on which they're based. For example, this panther anthro has been drawn in a catlike, slinky pose, showing her on the prowl. When she moves, she leaps from place to place, just like a cat. The "puppy" on page 106, meanwhile, crouches on four legs. Often, the hands and legs are converted back into their animal form; to lend a less human look, the bulldog has four fingers total instead of the full five. And a tail is sometimes added. Coloring is important, too; it should be the same as the actual animal in order to identify the species. Panthers are black, hence the primarily black costume here.

While some anthros have a more human head, like our panther, another type of anthro treatment occurs when an animal head is placed on a human, or partially human, body, as with the bulldog. These are the weirdest anthros around. As such, they're sometimes turned into giants so that they become a type of mutant. (You can never have too many mutants if you're a comic book fan.)

THE PANTHER

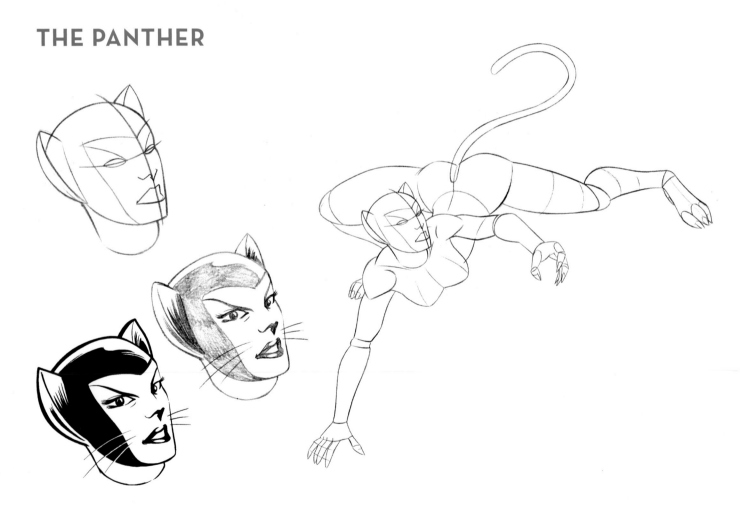

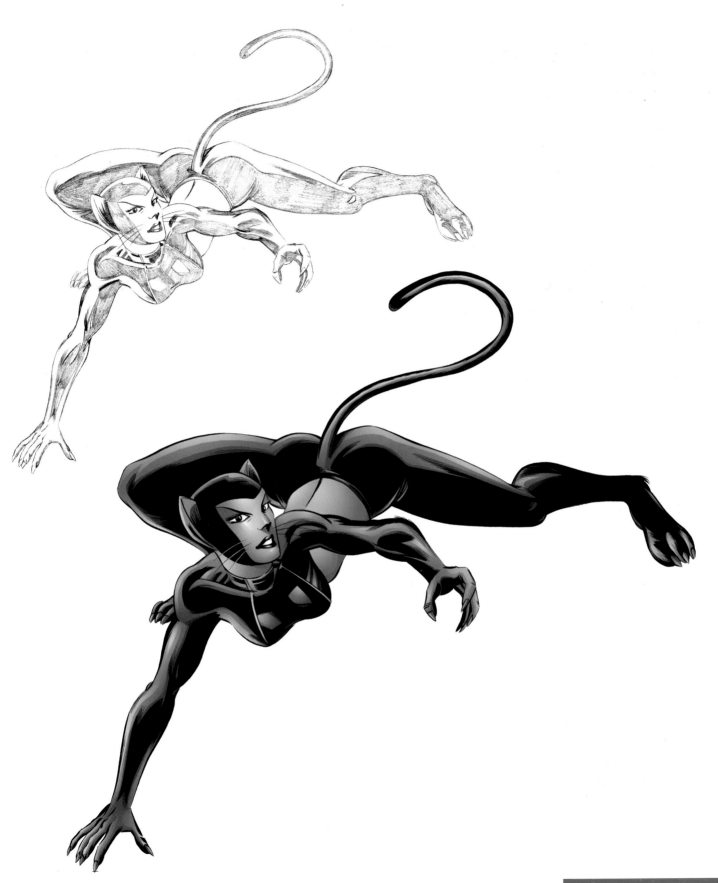

THE "PUPPY"

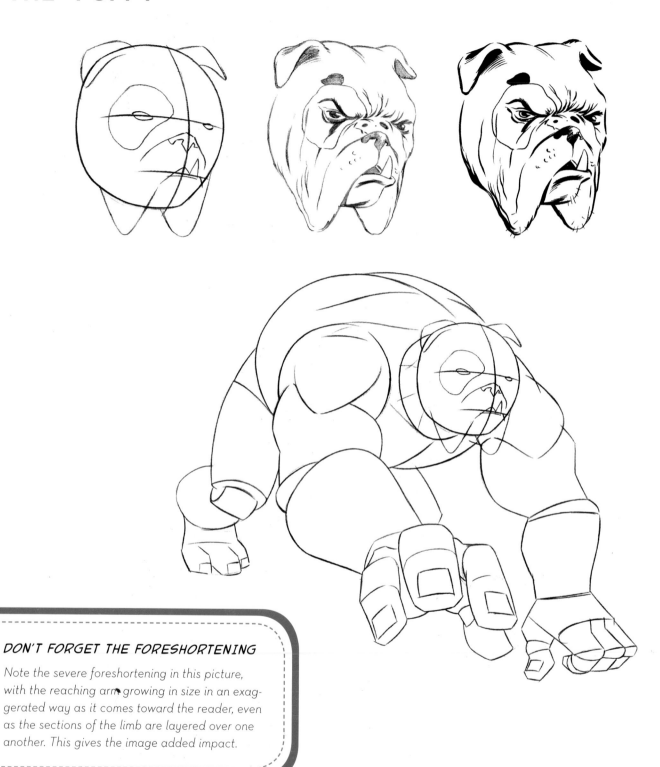

DON'T FORGET THE FORESHORTENING

Note the severe foreshortening in this picture, with the reaching arm growing in size in an exaggerated way as it comes toward the reader, even as the sections of the limb are layered over one another. This gives the image added impact.

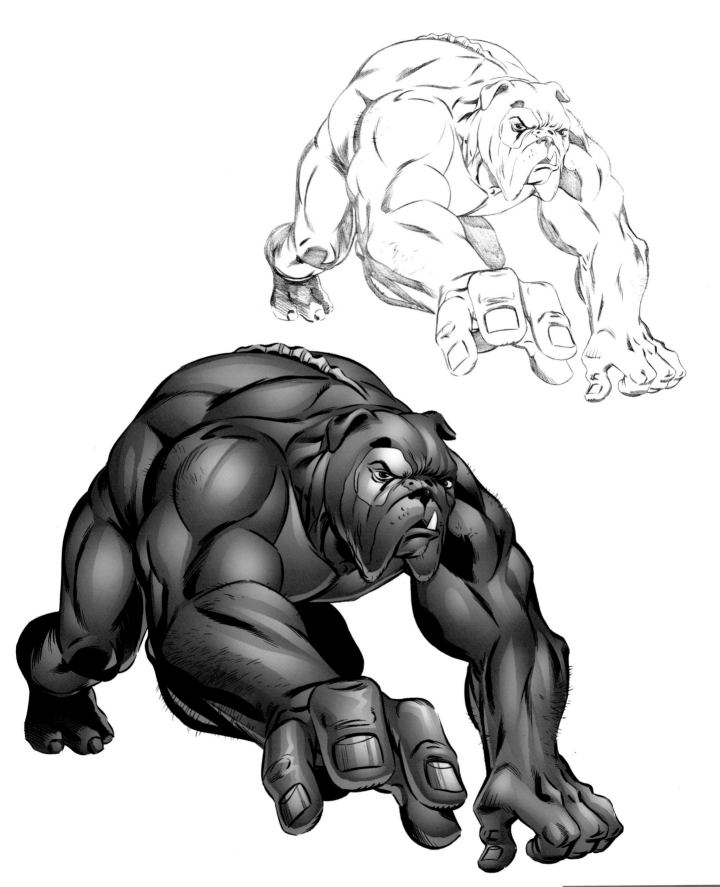

Drawing

SEXY GALS

Readers have come to expect a bevy of beauties in today's comics. An artist who wants to stay in demand by publishers should be able to draw them. Whether they're beautiful heroines or psychotic villains, gorgeous girls are one of the most popular aspects of the art. Here, you'll find sexy gals drawn with idealized proportions. They convey a sultry sensuality in their expressions and body language. But they're anything but meek. In fact, these knockouts are tough as nails. You'll also notice that they're often drawn looking directly into the eyes of the reader, seeming to look at you as you look at them. In this way, they draw you into the scene and under their spell.

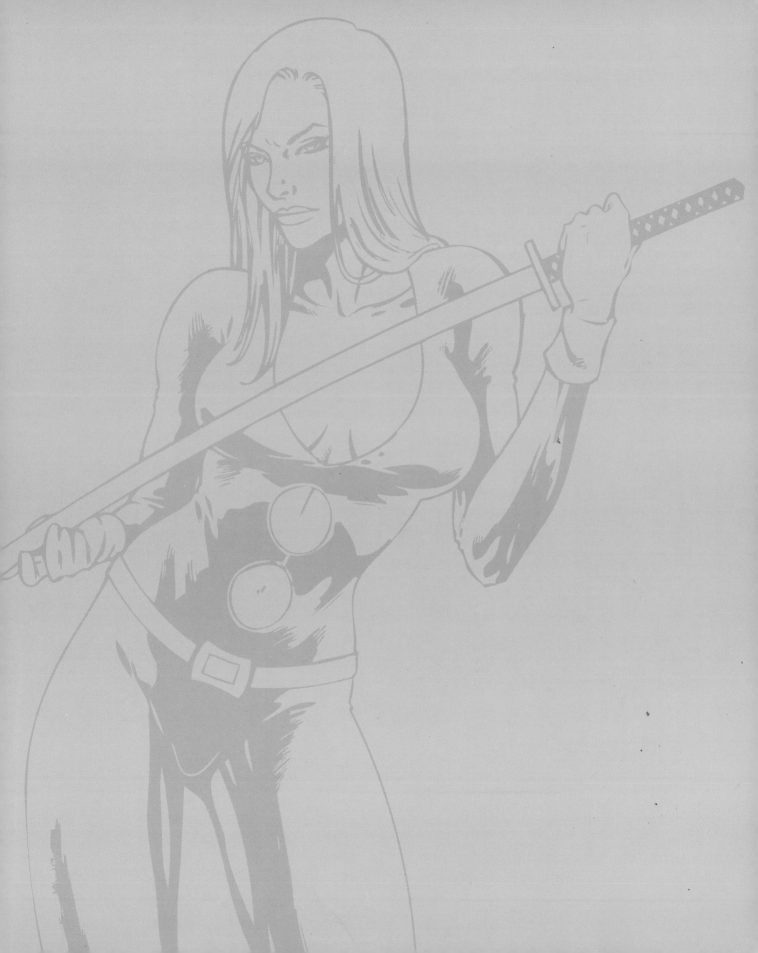

NOT JUST ANOTHER PRETTY FACE

More than just pretty, the sexy comic book gal's got dreamy eyes and kiss-me lips. How, exactly, do you draw these things? Make sure the eyelids hang heavily on the pupils so that the eyes are almost half closed. The lips are oversized and the mouth is slightly open. The jaw should be strong but supple. The nose is only partially defined on female characters; barely articulate the outline of the nostrils, and leave off the bridge of the nose. Female face masks have moved far beyond the simple costume-party masks of yesteryear; they're now extravagant, fashionable accessories. And for a finishing touch, draw hair that breezily surrounds her face and gently falls down to her collarbone.

Eye line.

Guideline for mouth falls at bottom of skull circle and top of jawline.

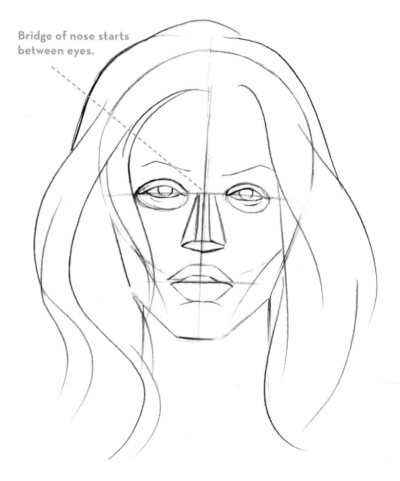

Bridge of nose starts between eyes.

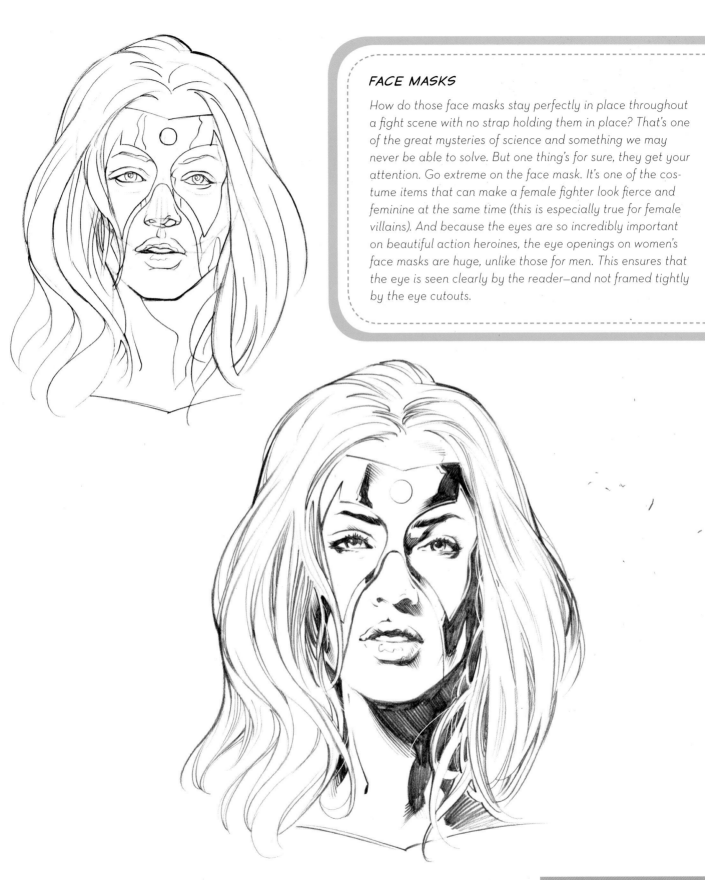

FACE MASKS

How do those face masks stay perfectly in place throughout a fight scene with no strap holding them in place? That's one of the great mysteries of science and something we may never be able to solve. But one thing's for sure, they get your attention. Go extreme on the face mask. It's one of the costume items that can make a female fighter look fierce and feminine at the same time (this is especially true for female villains). And because the eyes are so incredibly important on beautiful action heroines, the eye openings on women's face masks are huge, unlike those for men. This ensures that the eye is seen clearly by the reader—and not framed tightly by the eye cutouts.

SEXY FROM ANY ANGLE: PROFILE AND 3/4 VIEWS

Some beginners are in the habit of making the chin and tip of the nose pointed and the jawline sharp. But all this takes away from the softness of the female face. Everything should be curved.

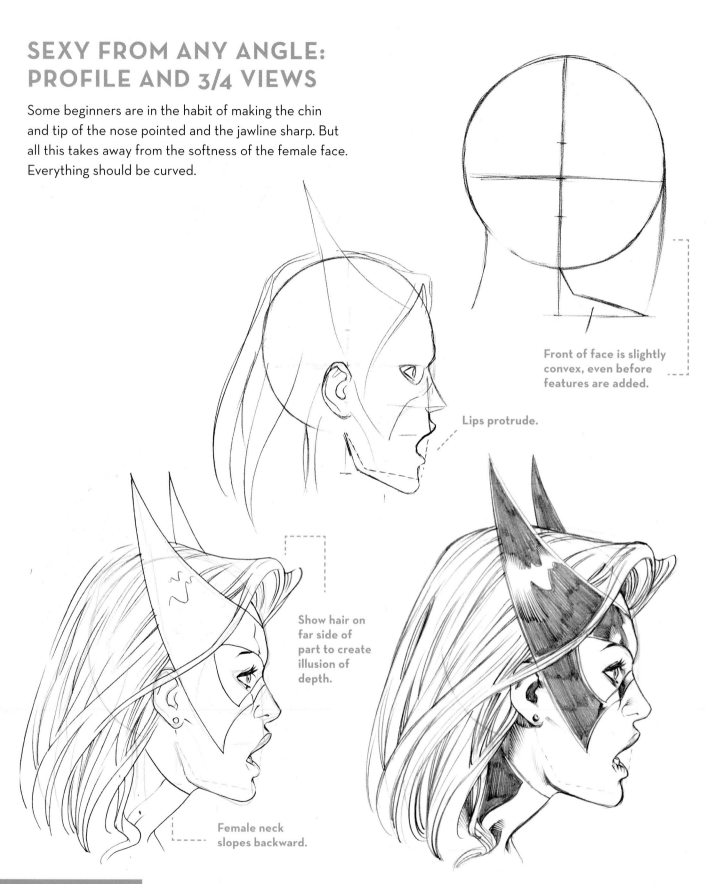

Front of face is slightly convex, even before features are added.

Lips protrude.

Show hair on far side of part to create illusion of depth.

Female neck slopes backward.

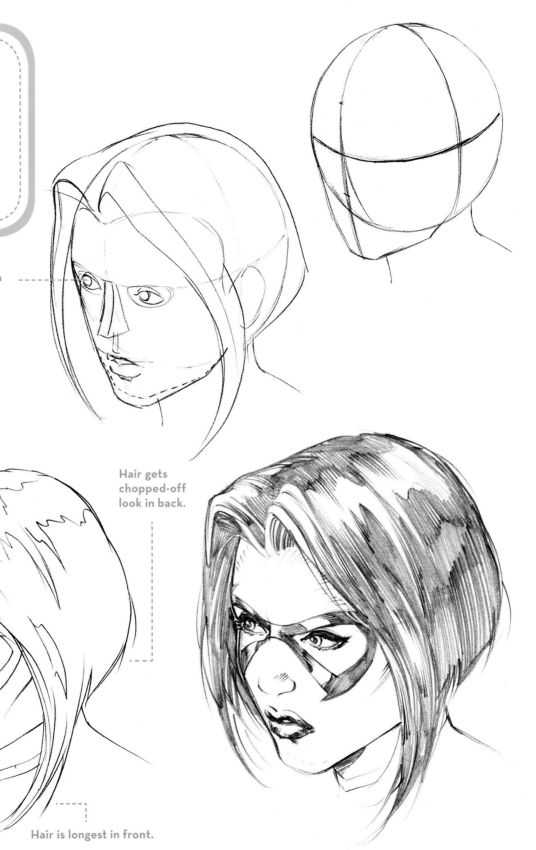

THE BOB

Not all sexy comic book gals have long hair. This hairstyle is called a bob. It's short, with a part in the middle, and wraps around the face. Make the hair longest in front, and chop off the portion on the back of the head.

Far eye is smaller than near eye in 3/4 view.

Hair gets chopped-off look in back.

Far side of mouth is shortened in 3/4 view.

Hair is longest in front.

HIRED GUN

Gals with guns are as popular now as they've ever been. So this character is a staple in today's comics: the dazzling assassin. She has a nihilistic view of life. To her, taking out a bad guy is just a job, cold and sweet. Hey, everyone has to make a living, ya know?

Assassins and spies generally wear shiny black "skin suits" and boots. Note all of the highlights that are created on the outfit simply by leaving large areas light instead of making it all black. The weapon is a serious one. It's not the kind of handgun a lady carries in her purse. There's a silencer visible on the tip of the nozzle. It's strictly professional grade. And her body language is a feminized sort of masculinity: She takes a typical man's pose (sitting in a chair the reverse way) and makes it look sexy. Head back, hair cascading down past her shoulders casually. Being bad never looked so good.

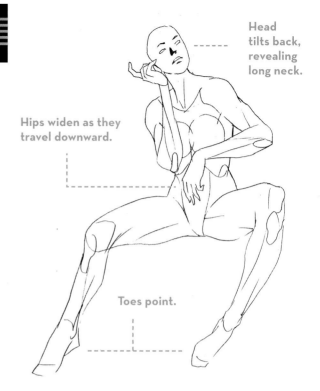

Head tilts back, revealing long neck.

Hips widen as they travel downward.

Toes point.

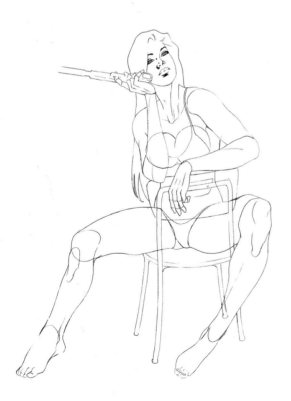

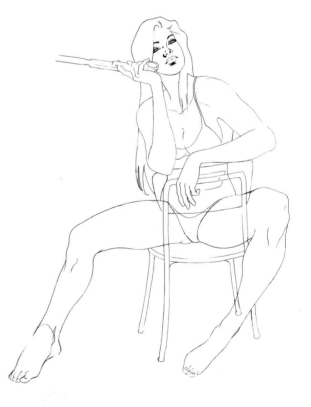

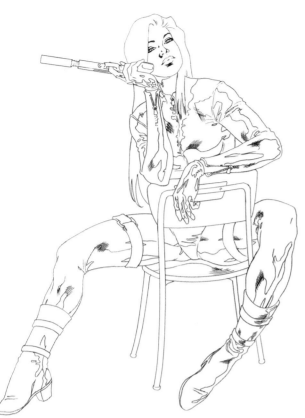

THE ORDER OF THINGS

Some artists like to draw the chair first, lock it in place, and then draw the body to conform to it. They feel it gives the character a greater look of solidity when things are drawn in that order. Others, however, prefer to draw the body first to get the pose exactly the way they want it. They add the chair later, making it conform to the body. Either way works fine, but make sure that the legs and buttocks compress at the point of contact with the surface of the chair.

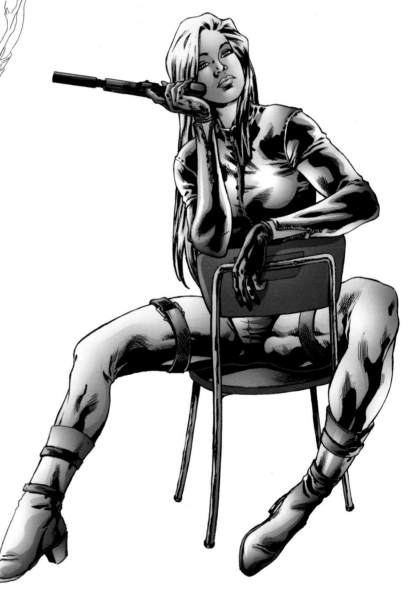

She's a warrior of the jungle, a savage princess—feral yet intoxicatingly beautiful. She's dressed in animal skins and adorned with the teeth of her kills and maybe even a skull of some foolish missionary. Note the arm and ankle bracelets, too. And that hair cascading down her shoulders. Giving her a slinky pose that's close to the ground suggests her animalistic nature.

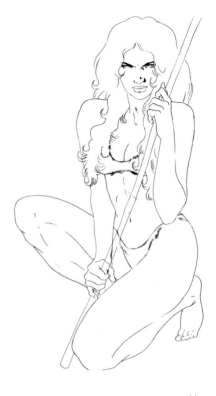

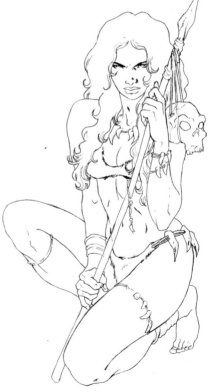

THE ATHLETIC FEMALE FIGURE

Always show a thin waistline with wide hips, which give her sex appeal and also make her physique powerful. Small, boyish hips are no good on female characters. Comic book action heroines don't promote the unhealthy thinner-is-always-better images so prevalent in other media. The legs are always full and shapely but without the harsh, articulated muscles seen on male superheroes. The interior muscles on women's legs are mostly left undefined.

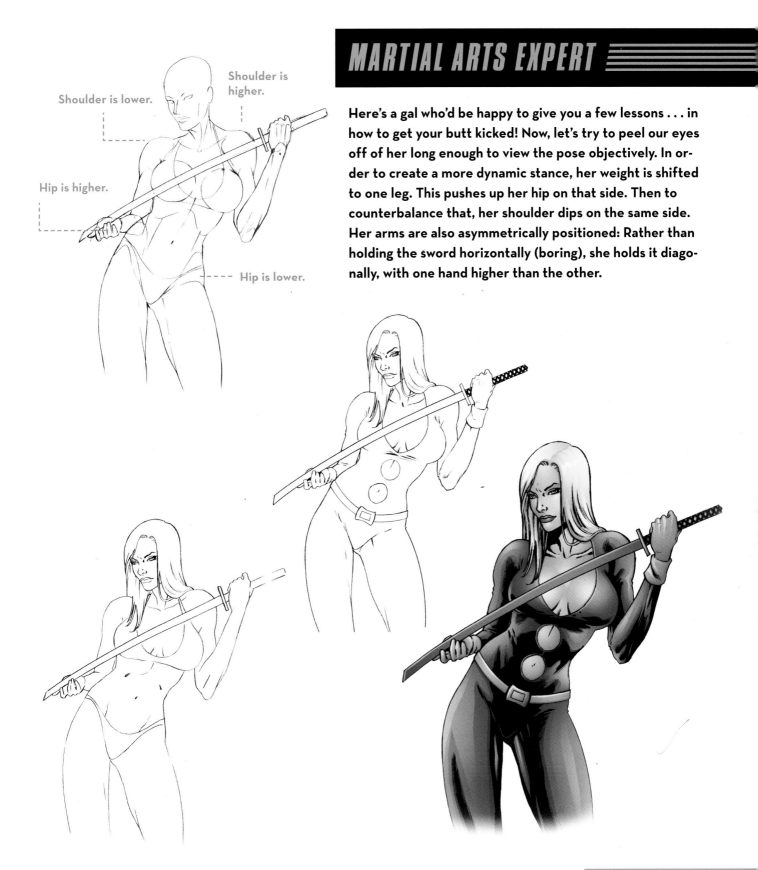

MARTIAL ARTS EXPERT

Shoulder is lower.

Shoulder is higher.

Hip is higher.

Hip is lower.

Here's a gal who'd be happy to give you a few lessons . . . in how to get your butt kicked! Now, let's try to peel our eyes off of her long enough to view the pose objectively. In order to create a more dynamic stance, her weight is shifted to one leg. This pushes up her hip on that side. Then to counterbalance that, her shoulder dips on the same side. Her arms are also asymmetrically positioned: Rather than holding the sword horizontally (boring), she holds it diagonally, with one hand higher than the other.

Comic Book
LIGHTING

Comic book lighting is more dramatic than most light seen in real life. To achieve this very stylized look, there is frequent use of light and shadow. Shadow is used in comics for several reasons. First, it creates more intensity. Second, it makes objects look real and three-dimensional. And third, it causes characters to pop off the page. Let's take a look at how it's done. Use of light and shadow really separates the beginners from the more experienced artists, so let's venture into some deeper water and see how it's done.

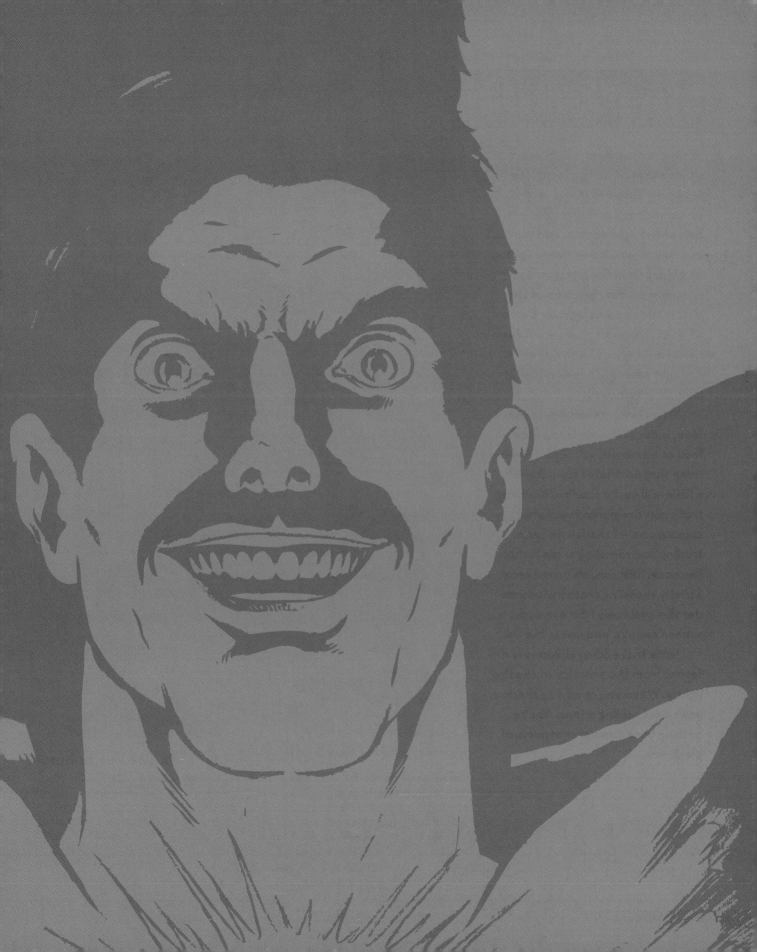

LIGHT AND SHADOW

Whenever you have a light source, shadows result on the forms the light hits. These shadows vary in placement depending on the position of the light source, and they act in a logical way. If you throw light at an object from the left, you'll get a shadow on the right side of the object. Shine some light on the top of an object and a shadow will form below it. Shadows form opposite the light source. They don't have minds of their own.

When adding shadows to the face, think of the surface of the face as a smooth, flat plane. Anything that protrudes from it even a little will cast a shadow. Anything that sinks down into it will also cause a pool of shadow to form. Protruding and receding areas include the nose, hair, lips, chin, and brow. Strictly receding areas include under the eyebrows (the eye sockets), sunken cheeks, and under the lips.

Note that adding shadows is different from the practice of shading lightly. When you're adding shadow, you're not adding a tone. You're bathing your character in pools of blackness.

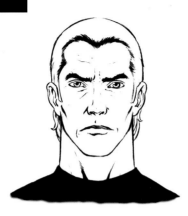

No Light Source

The candle is not yet illuminated, so the figure exhibits no shadows and has limited impact.

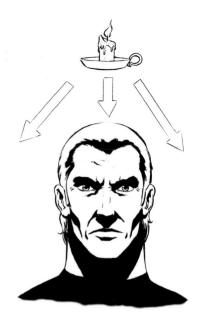

Light Source Directly Overhead

Overhead light casts shadows downward onto the face and neck. This is harsh lighting and not used as often as sidelighting.

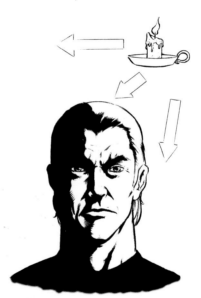

Light Source Slightly behind and to the Right

This is closer to regular sidelighting, the most commonly used shadows in comics. The light illuminates the right side of the face and part of the left, leaving only the left edge of the face in shadow. This results in a good amount of intensity but with enough light to still see all of the visage.

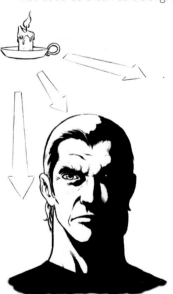

Light Source Far behind and to the Left

Light hits the character diagonally, throwing shadows over almost all of the right part of the face and neck. In fact, the right side of the face falls into almost total darkness. It's a very moody look—excellent for comics.

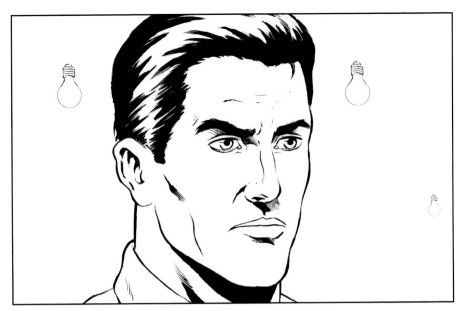

Omnidirectional Light

Omnidirectional light produces the same effect as no special lighting at all: It eliminates the shadows. Where would you have so many light sources? Interior office lighting but not many other places.

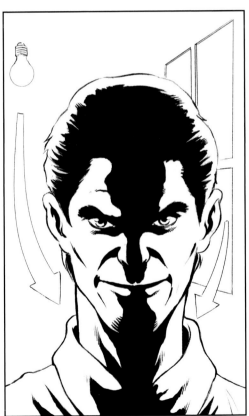

Opposing Light Sources

Having light sources on both sides of a figure is a very cool look, pooling up black shadows vertically down the middle of the face. It's often seen in comics at intense moments.

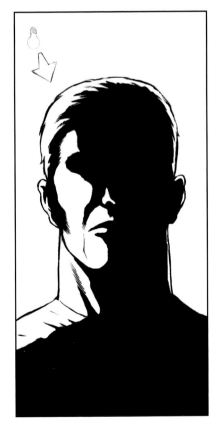

Faint Lighting

Low-voltage light appears in environments such as dark warehouses, prison cells, in creepy castles. The effect it yields is called *edge lighting*, because the rim of the darkened figure is illuminated.

LOW-ANGLED LIGHTING

Lighting that comes from below creates an ominous look by casting shadows upward. It's the look of evil, madness, fear, and panic. You want instant mood? Go with low-angled lighting. The light doesn't have to be directly below the face, although it can be; frequently, it's low and off to the side. This is also an angle that's frequently used to cast a large shadow on a wall or other surface behind a character, which adds an additional feeling of menace.

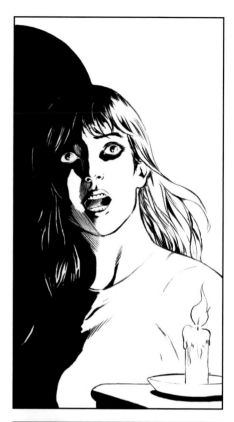

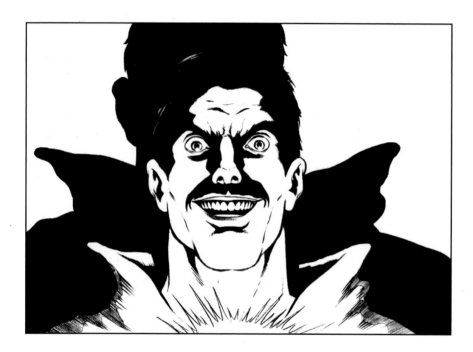

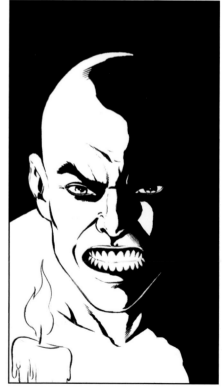

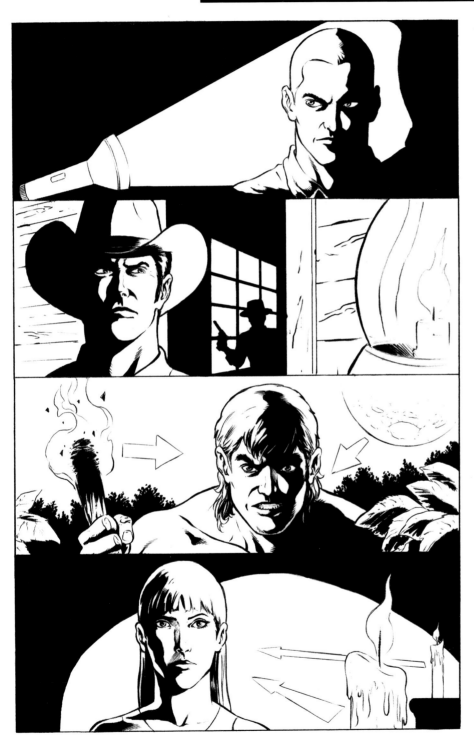

Single light sources (the top two panels) result in part of the face being completely engulfed in shadow. Double light sources, however, have a different effect: They result in a face with some rim lighting on the shadow side.

In double-light-source situations, one light is often stronger than the other. In the third panel, the torch is the strong source, while the moon is the weak source that casts only a tiny bit of light that results in the rim lighting. The light source that's nearer the rim lighting is usually the one that produces that effect. So in the fourth panel, the near candle, which is closer to the rim-light side, is the one that lights up the left edge of the woman's face so that it doesn't fall completely into darkness but has a brilliant edge to it.

LOW-LIGHTING A CHARACTER

Our starship commander is looking at his ship's control panels and doesn't like what he sees: enemy vessels, six of them, coming right at him. For a tense moment like this, "underlighting" (light that comes from below) is a good choice. It increases the intensity twofold. Here, the lights from the control panels would serve as the light source for the low lighting. Remember, any feature that protrudes from the flat plane of the face will cast a shadow, and in the case of low lighting, those shadows aim upward on the form.

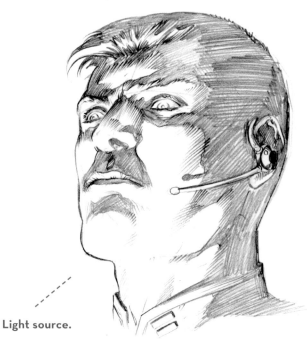

Underside of nose is also apparent at this angle.

From this low angle, underside of jaw is seen.

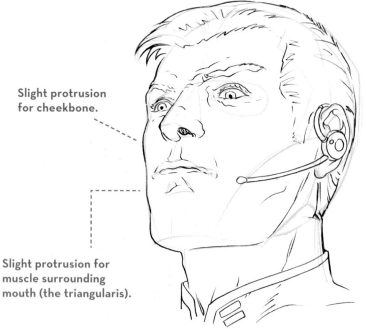

Slight protrusion for cheekbone.

Slight protrusion for muscle surrounding mouth (the triangularis).

Light source.

TOP-LIGHTING A CHARACTER

Light that shines down from above casts harsh shadows and creates the appearance of deep pockets under the eyes. It gives characters a hardened look that's perfect for barbarians, those terrible brutes from some parallel world. Due to deep shadows, this would appear to be a nighttime scene with moonlight as the light source. Note how the bottom of the face literally disappears into the spreading shadows, melding with the neck and hair. Keep in mind, though, that even if a portion of your finished line work will end up obscured by shadow, you still need to sketch the entire face to start—yep, even the part that eventually gets blanketed with darkness. Don't use the shadows as an excuse to draw only half of the character.

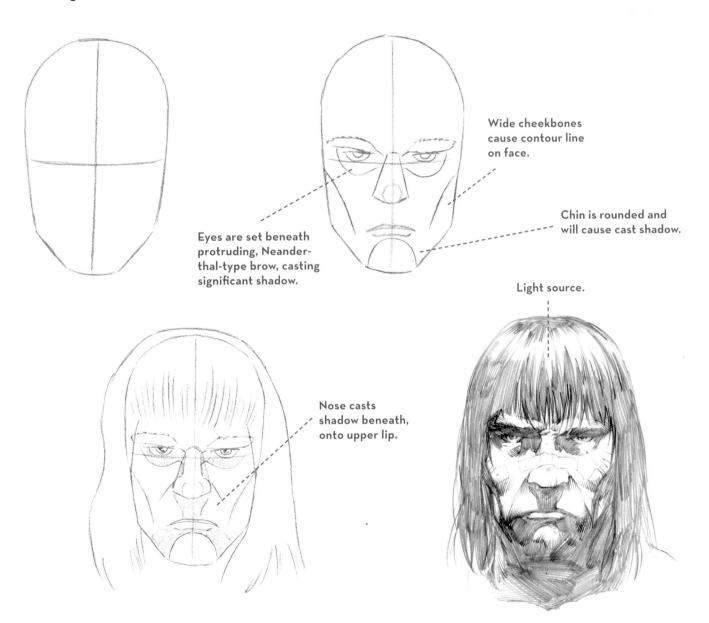

Eyes are set beneath protruding, Neanderthal-type brow, casting significant shadow.

Wide cheekbones cause contour line on face.

Chin is rounded and will cause cast shadow.

Nose casts shadow beneath, onto upper lip.

Light source.

JUXTAPOSING BLACK AND WHITE ≡

Here's a pro secret that's used all the time by top comic book artists but almost universally neglected by beginners: Use lots of black in designing a scene. These can be in the forms of shadows, silhouettes, or partial silhouettes. To make the blackened objects pop off the page, you have to position them against white spaces. This is called "checkerboarding."

Silhouetted Foreground

Here, the two figures plus the near building have been rendered primarily black, in essence silhouetting the foreground. The buildings in the background remain white. The contrast between foreground and background immediately brings depth to the image. And because of the shadowy fighters, the scene also looks quite ominous.

Simple Line Art (White on White)

Although this rooftop fight scene is a good drawing, with heavy action, it's strangely missing impact. That's because basically no black areas have been added to the picture.

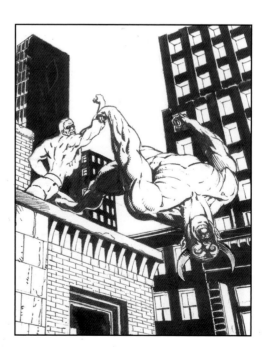

Silhouetted Background

Now the background buildings are blackened, while the foreground figures and building remain mainly white. As with the silhouetted areas in the previous example, note that the background buildings aren't total silhouettes in the strictest sense of the word; the artists cheat a little, adding white areas to the interior of the black forms to define the windows and other architectural elements.

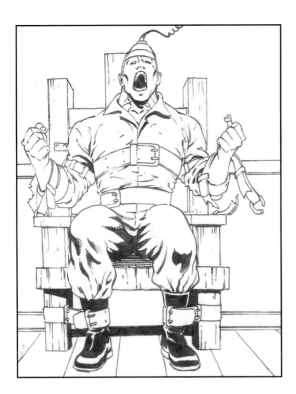

Simple Line Art (White on White)

In this death-row escape scene, unfortunately for us, our killer is snapping loose from his restraints! This simple line-art treatment, with primarily everything left white, doesn't seem intense enough to capture the ferocious mood of the scene. We'll have to go in and do some quick repairs.

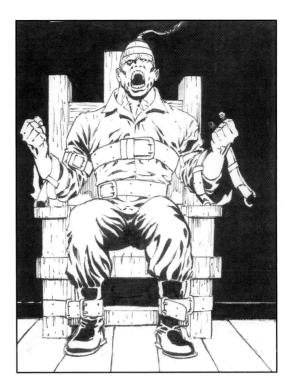

White Figure, Black Background

When the background is darkened, the figure really pops off the page, and the intensity screams at us.

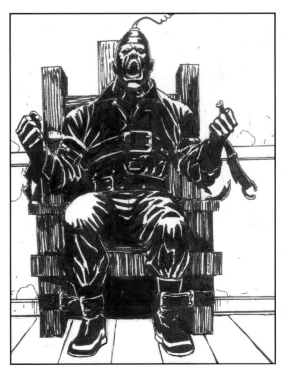

Partially Silhouetted Figure, Background White

This effect gives the prisoner an almost otherworldly appearance, as if the electricity were giving him immense strength. Bathed in shadow, with harsh highlights, he now appears superbad. (Note his white highlights.)

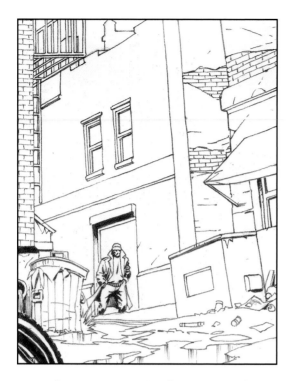

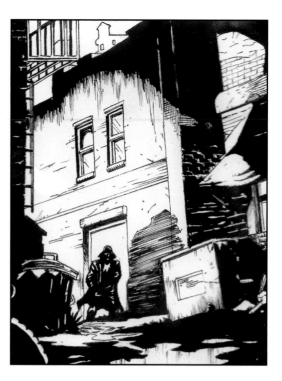

Simple Line Art (White on White)

You could create an effective mood by using just color; however, the classic dark alley should look run-down, moody, and intense, with shadows to create a noir flavor.

Figure in Silhouette

Having the silhouetted figure walk against a white building allows a large, ominous shadow (from the figure) to be cast against the side of the building.

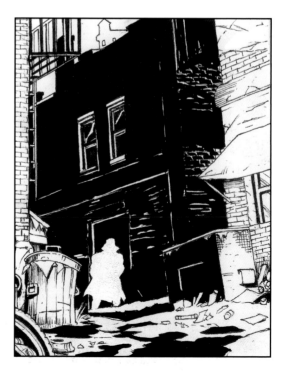

Figure in "Negative Silhouette"

Here, the man is left white, while the building lies in shadow. "Negative silhouettes" draw your eye directly to the character.

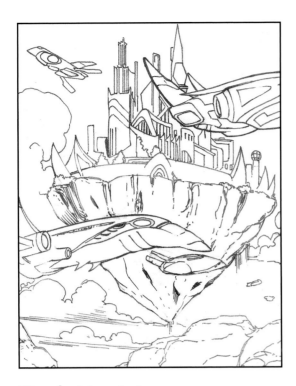

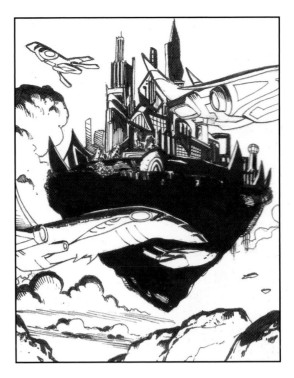

Simple Line Art (White on White)

This sci-fi castle in the air illustrates a problem that comes up frequently: There's so much going on in the scene that it's getting confusing. How do you fix this? By juxtaposing black and white areas.

White Foreground, Partially Silhouetted Background

The contrasts of the black and white areas help define the forms within the scene. Now when color is added to it, the scene will read clearly.

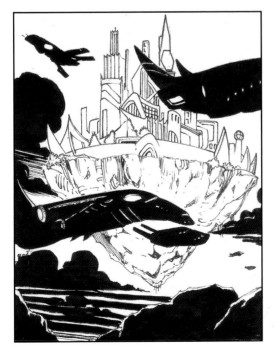

Silhouetted Spaceships, White Background

Here's another option for juxtaposing black and white areas in this scene. Silhouetting the spaceships gives them a menacing look. Merely adding black has turned them into warships of the sky.

CHAPTER **8**

Essential Comic Book
ELEMENTS

There are certain elements that are common to all comic books: the splash page, speech balloons, good character placement, effective panel sequencing, and cool locations. And the skilled artist must use them all. Capturing, directing, and focusing the reader's eye is the great quest of every comic book artist who attempts the splash page, or "pinup." As you'll see, a pin-up is a full page of jam-packed action. It can be an interior page, but a cover is based on the same principles. Then, we'll break down the sequential storytelling process so that you can begin to lay out your scenes into panels with speech balloons. Pretty soon, you'll be taking over the whole world!

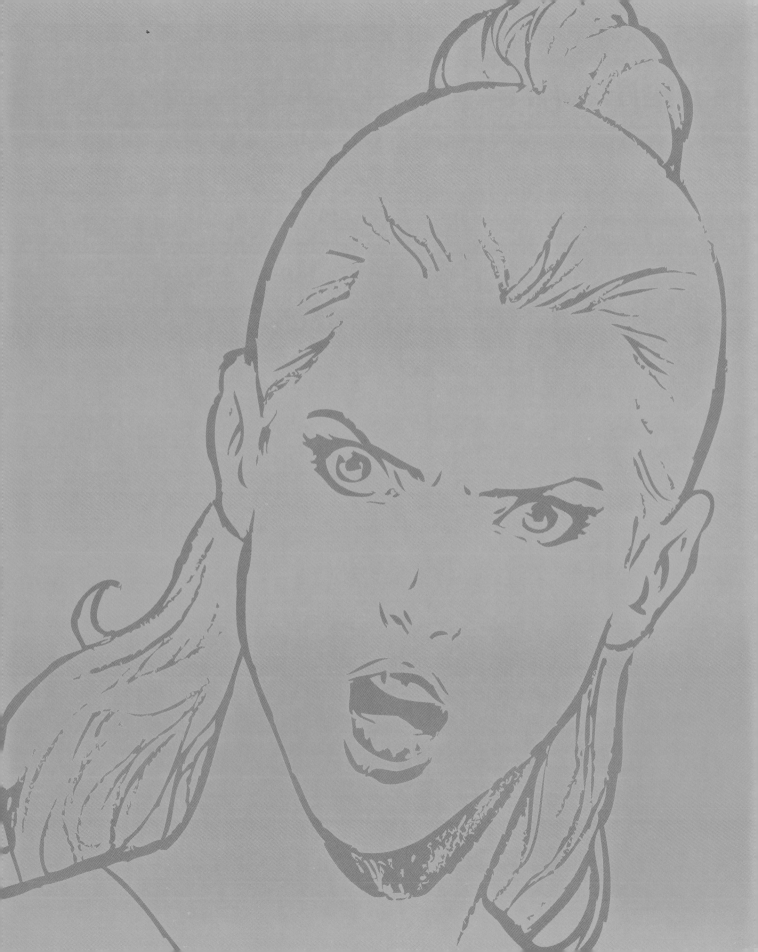

THE SPLASH PAGE

The splash page, also called a pinup, is a scene that takes up not just a panel but the entire page. So you know it has to be exciting, with lots of action going on. These are important moments in the story. They are the visual payoff, the reward, the reader gets after the buildup to the climax.

Drawing the splash page takes a little planning. Don't just go in and start drawing figures anywhere.

The page is a large canvas, and you don't want the eye to be confused by a gang of characters poorly laid out on it. Your job is to direct the eye so that it continues to look at the picture. You want the reader to gaze at the splash page, not just glance at it. To do this, you need to create a *circle of focus*. If, when looking at a picture, the eye gets stuck on something conspicuously placed in a corner of the page or if the characters don't lead the eye from one to the other, then the picture won't hold the reader's attention. By placing the main elements of the action on a continuous loop, you keep the eye from traveling out of the scene.

Poor Layout

The characters are positioned haphazardly and overlap one another awkwardly. This makes it difficult to read the action clearly and therefore does not get the eye involved in the scene because things look cluttered.

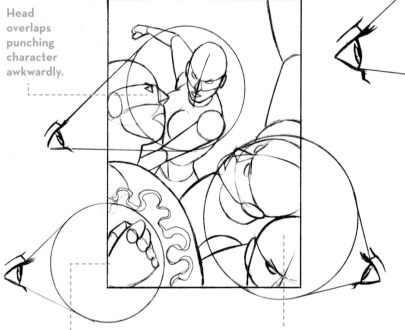

Head overlaps punching character awkwardly.

Fist sticking out of corner draws too much attention to itself.

More focus in corner draws eye away from center of action (punching figure). Plus, two heads touching is poor staging.

Good Layout

The circle of focus is now clearly on the punching figure. The other characters surround her in a circle, giving her room to breathe but framing her as the center of attention. Now the eye wants to focus on her. Even the fist in the lower left corner is no longer a problem, because it is part of the circle framing the woman.

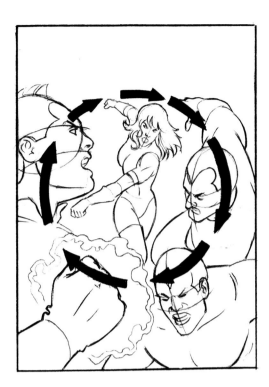

Continuous Flow Established

When the figures are sketched in a little more definitively, the circle of focus becomes even clearer: A circular path through the layout creates one continuous loop, keeping the eye from wandering off the page.

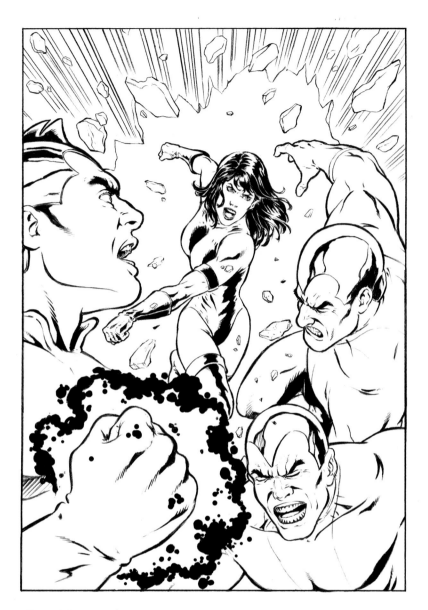

Final Layout

Putting it all together, we can really feel the punch. We also experience the impact those bad guys are feeling from it. The action is clear and uncluttered. And we get a good sense of depth from the contrasting placement of some figures in the foreground and others in the background. The radiating, exploding surroundings reinforce the circular placement, as well.

Color Version

Color is also used to reinforce the circle of focus. The most intense color, red, is at the center of the storm, used on the costume of the central figure, which draws your eye into the scene. The grays (the helmets and gloves) tie together the edges of the scene in a circular motion, keeping the eye from leaving the panel. The background is gradated rather than one solid tone, which again focuses our attention on the central figure, where the color implies it appears to be the hottest.

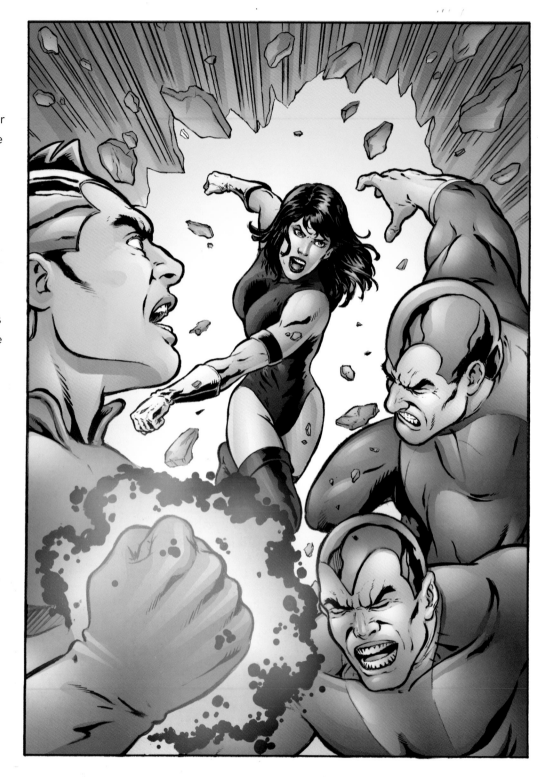

WHAT MAKES FOR EFFECTIVE LAYOUT?

The elements that make this panel layout work will apply to any good splash-page composition. To start, the central punching figure has a good amount of surrounding space so that the action doesn't appear cramped. This is very important. The figures are positioned in a staggered way—one in the foreground, one in the middle ground, and one in the background—to create a sense of depth.

Additionally, there's a clear sequence of action: As one mutant is dispatched with a punch, another is about to jump in to attack. And to play up the action, the foreground figure is greatly exaggerated, displaying an extreme use of foreshortening with forced perspective, to make him larger and therefore give him more impact as he falls toward the reader. Take that, you pointy-eared slimeballs! Mutants just get on his nerves, don't they?

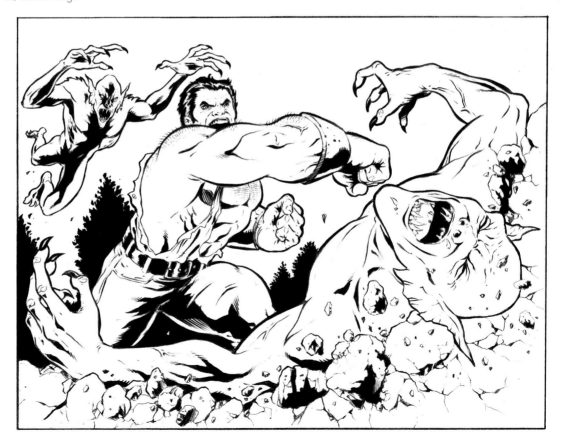

USING THUMBNAIL SKETCHES

Small, diagram-type sketches in which the characters are drawn roughly just for placement are called *thumbnails*. They're invaluable for laying out a scene, because they're so simple that you don't feel married to any particular drawing. If one isn't working, try another. The point is to not invest a lot of time in rendering the thumbnails.

And don't fall in love with the first one you do, even if you like it. Try several variations. You can then take the best from each and combine them into one effective splash page.

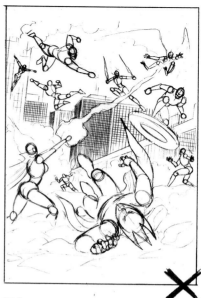

Wrong

This one's really a mess. There's no rhyme or reason to the layout. Plus, the creature, which has fallen to the ground, is the same size as the woman. That means the creature's not going to look impressive or threatening.

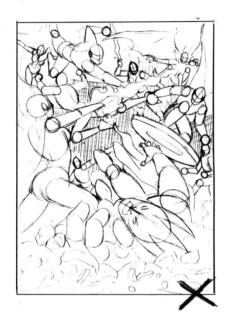

Wrong

Everyone in this thumbnail is too far from the reader. Nothing is up close to create that in-your-face perspective for which comics are famous. This one's a yawn.

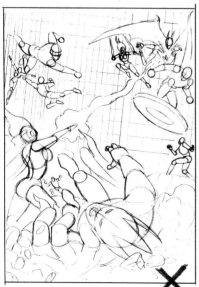

Wrong

Better. The creature is now the biggest character in the picture. But he's too far over toward the woman, who's the heroine of the scene. He's crowding her and needs to be moved over a tad to the right.

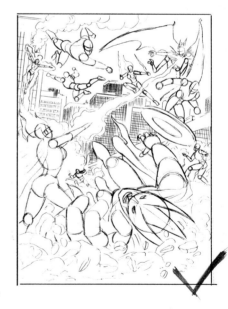

Right

Yep. This is the one. Did you notice how the eye goes from one character to the next in a circular path? The heroine and that burst of energy are the center of focus. Everything leads back to that. Plus, she's got more room around her than any other character, because she's the star of the page.

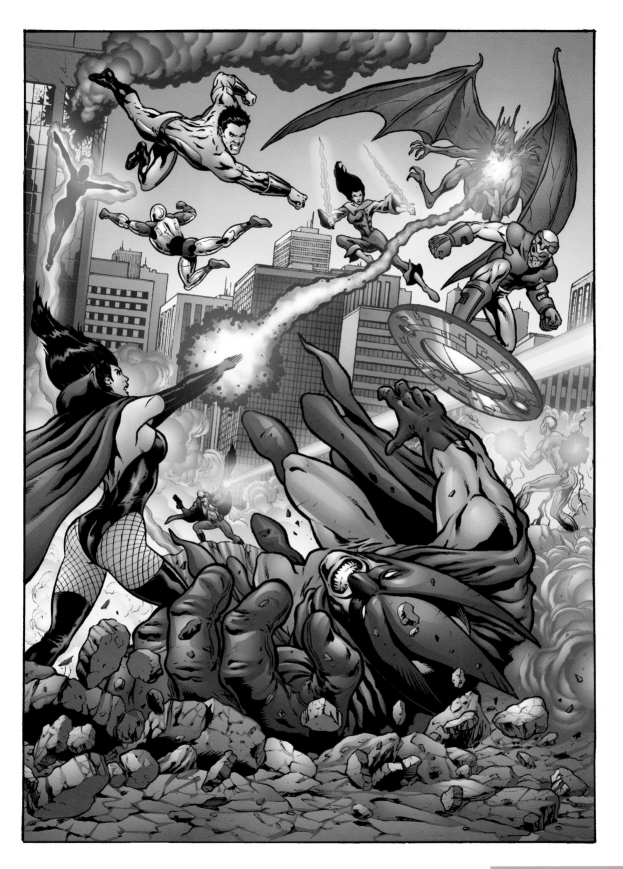

TEAM SPLASH PAGES

In addition to creating climactic scenes, the splash page is also an important tool for establishing the superhero team. You can tell who the leader is by that character's position in the group: front and center. The others should display their powers, which will key the reader in to the unique traits each possesses. Note the pleasing effect of the circular layout, which is just as important in team splash pages as it is in "nonteam" splash pages.

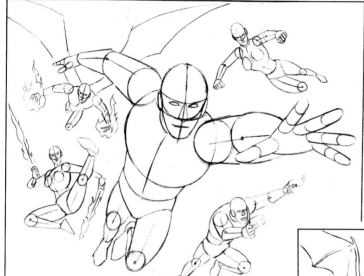

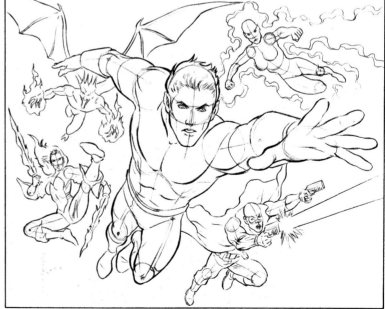

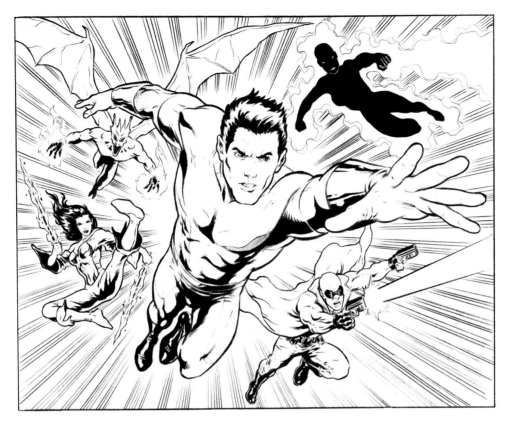

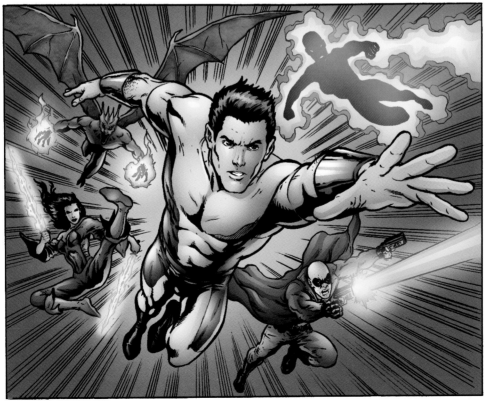

SUPERVILLAIN TEAM SPLASH PAGE

Supervillains generally have more extravagant costumes than superheroes, if that's even possible. They're also shown smiling—as they anticipate the mayhem they're about to cause. Like superhero teams, villain teams have a leader and cast members with different talents. The layout concepts are also the same: All supporting characters fall on the periphery, orbiting the leader and creating an effective circle of focus. Note the forced perspective of the leader's pointing hand, which mirrors the outstretched hand of the superhero leader on page 139.

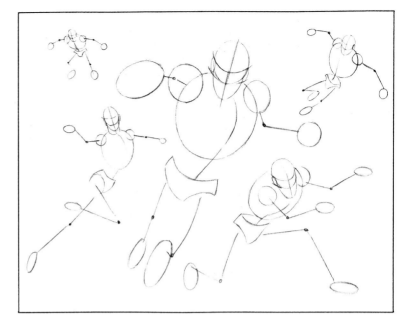

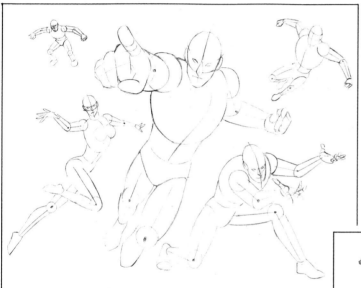

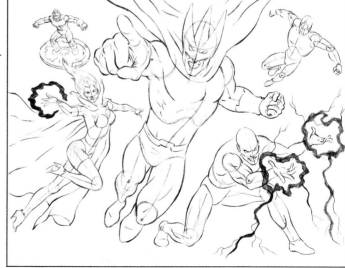

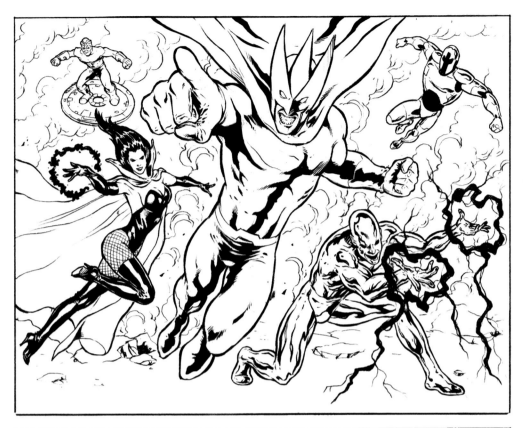

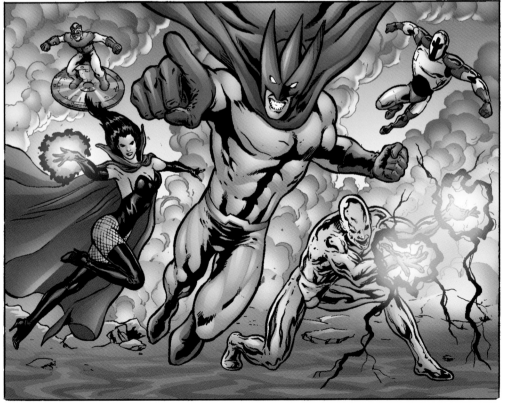

SPEECH BALLOONS AND CAPTIONS

Speech balloons are first read left to right and then top to bottom. The primary direction is always left to right. Poorly placed speech balloons cause consternation. The reader has to reread the balloons in a different order to make sense of it, and that slows down the flow of the story. The last thing you want to do is frustrate your reader with speech balloons that are laid out confusingly.

Captions are the rectangular boxes set with quick snippets of information to cue the reader into the scene (like box 1).

Incorrect Placement (top)

Oh boy, look at this. After all of that hard work drawing a perfectly good scene, don't ruin it by obliterating it with caption boxes and speech balloons. And the reporter looks like he's wearing speech balloon 4 as a hat!

Correct Placement

Counterclockwise placement of caption boxes and speech balloons is effective, provided that these elements still read from left to right and that they leave the main point of the image uncluttered.

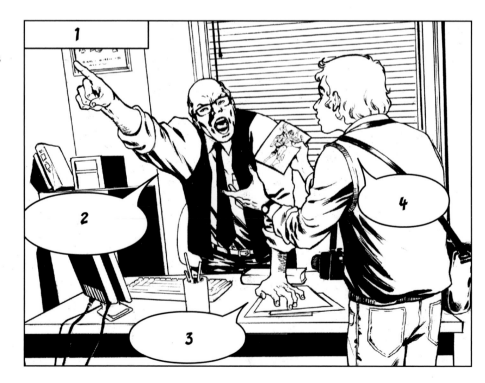

Incorrect Placement

The reader is likely to skip the balloons in the wrong order, missing the meaning of the scene. In addition, never let me catch you covering your character with a caption or speech balloons, as has been done here!

Correct Placement

Starting with the caption box, the text elements read left to right, top level first, and then left to right again on the bottom level.

Incorrect Placement

Here, the speech balloons invade the center of the scene and steal the focus away from the characters. In addition, their order is all mixed up.

Correct Placement

The two characters at the top of the page are engaged in a dialogue and therefore must speak sequentially; that's why balloon 3 must follow balloon 2.

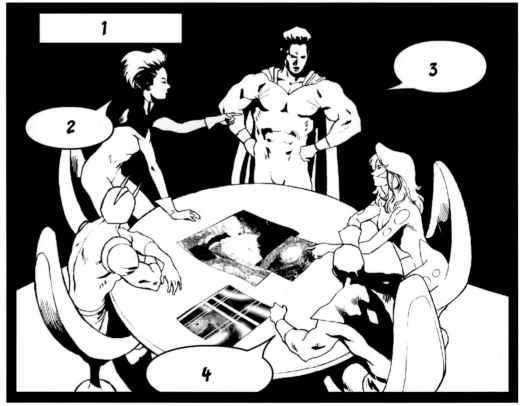

EFFECTIVE PLACEMENT OF SPEAKING CHARACTERS

In addition to good speech-balloon placement, you also need effective positioning of characters who are having a dialogue. There are many ways to stage two figures talking, and the three most frequently used positions are shown here. They're clear and effective.

Facing Each Other

Be careful not to draw both characters in profile. That's a beginner's trap that you don't want to fall into. One, or both, of the characters should turn into a 3/4 view to add variety and avoid a flat look. Here, he's in profile, while she's in a 3/4 view.

Both Facing Front

In this picture, he's looking back and talking to her, but he doesn't have to look back for this staging to work. It would also be effective with him looking forward while speaking to her. He doesn't have to actually look at her.

Reverse Angle

Here, we look over one character's shoulder at the other character, who's doing the majority of the speaking. When it's her turn to reply, you can reverse the angle, so the reader is looking at her over his shoulder. That's how it's done.

What's most important in laying out a comic book page is that the story flows from one panel to another. It's got to clearly communicate to the reader what's going on in the scene (and the overall story). Any confusion has to be avoided. But that's just the beginning. More than mere clarity, you also want to create some impact. And that means adding a variety of different shots. Some moments in the story will, by necessity, be more important than others. You'll want to emphasize those more important moments with special shots and angles.

Too often, beginners do too much in full shots, so their comic book pages are filled with characters drawn from head to foot, with no close-ups or medium shots. Beginners also depict everything head-on instead of at angles, such as up, down, and tilted somewhere in between. To move beyond the beginner stage and start to express continuity of scenes from a dynamic perspective, we'll use a city scene in which a couple is held up by a mugger with a gun. Suddenly, our superhero arrives to save the day. This is a classic comic book moment, so it'll make a good example.

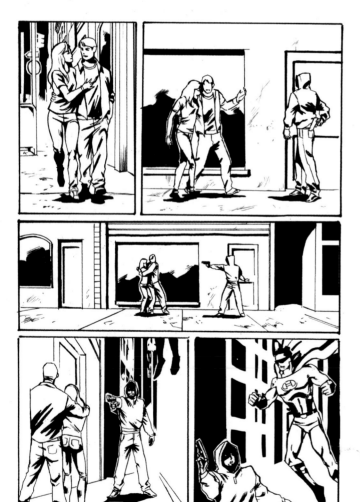

Beginner Approach (left)

What's right? Some of the shots are varied, and some placement of the characters in the panels is good. What's wrong? There's repetition of the main event in a few of the panels, with no close-ups or medium shots to jar the reader. Readers want sudden surprises. This is a sleepy page.

Pro Color Approach (opposite)

The first shot is neutral to set up the story and give the reader information fast and simple. Danger starts to happen in the second and third panels, which is why the angle has been *tilted*. Then we go in tight for a couple of quick close-ups of the dangerous guy in panels 4 and 5. In panel 6, the shot widens out because it's an important moment when we see the superhero descending. An "up" angle (looking up at the figure and sky) is used because it makes a character look powerful. All four characters fit into this last shot.

Once the color is added, it all comes together. Many beginners are fearful about learning how to color comics on the computer. But the truth is that the penciler, the inker, and the colorist are almost never the same artist. That means it's not at all necessary for the penciler or inker to know how to colorize his or her own drawings. The comic book publisher hires people to do that. Whew! You're off the hook!

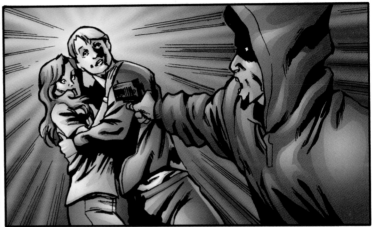
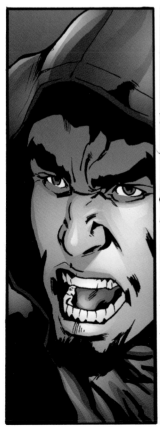
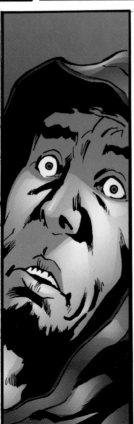
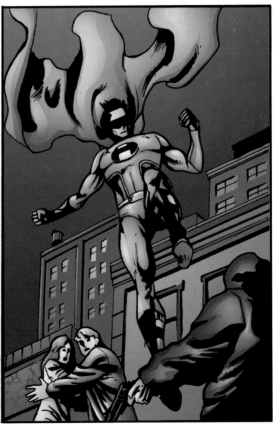

Beginner Approach

Here's the setup: A buyer is purchasing some arms from a gun smuggler. He checks out the weapons, likes one of them, and holds up the arms smuggler with it! So, what's right? The location is good, and selling weapons out of a car trunk is a good idea. It makes the transaction look covert and illegal. What's wrong? Every panel looks similar. There's not much variety of angle, and the characters are all basically fully drawn. There isn't one moment that's been highlighted by way of an interesting angle or a closer shot.

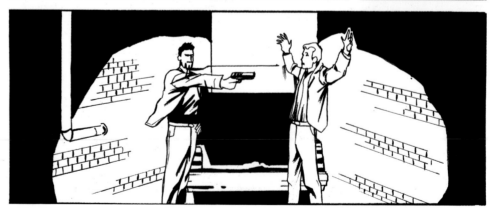

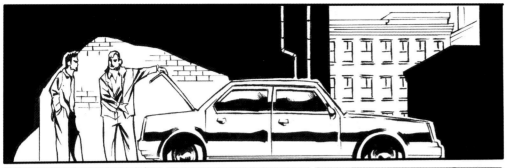

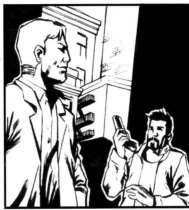

Pro Approach

Note the close-up of the guns. That's called a detail shot. It forces the reader to take note of a specific object by getting close to it and isolating it. Other common subjects for detail shots include a ringing phone, a knife in someone's hand, and the combination dial on a safe. But back to this panel sequence, the shots are all varied. There are long shots (panel 1), full shots (panel 2), medium shots (panels 4, 5, and 6), and close-ups (panel 7). Note how the gun appears in the foreground in the last panel to emphasize its importance.

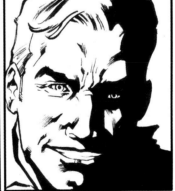

Beginner Approach

Again, here's the setup: Some Navy SEALs are furtively approaching a submarine in the water. They sneak under the hull, attach a bomb, and swim off. What's right? Good feeling of being underwater due to the large panels. Clear flow of action. Good design of the scuba outfits. What's wrong? Every shot is at a distance, so readers cannot get involved or excited about the action. They stand removed from it. The angles are also too mild for such a dramatic and dangerous operation.

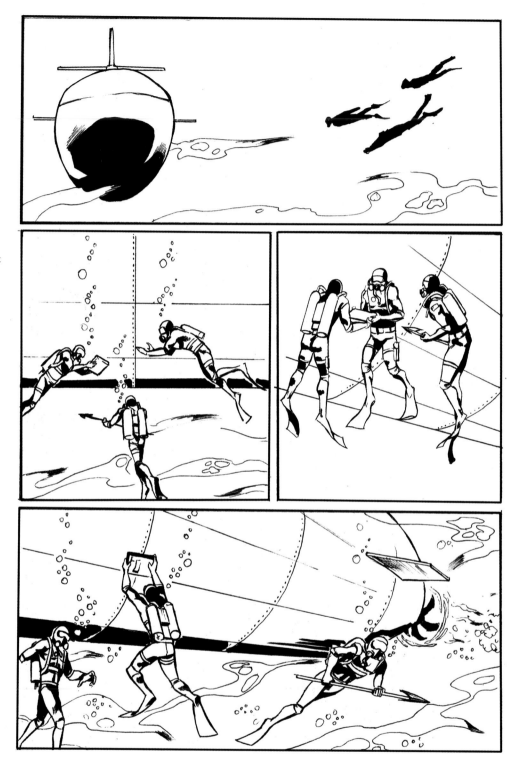

Pro Approach

The scene starts off with the men and the sub at different heights: The men have to swim up to the sub. This immediately makes things more dramatic than the first version, in which the SEALs were swimming horizontally to a sub directly in front of them. The second panel is a tried-and-true classic: It's a reverse angle, meaning you're looking at one person over the other person's shoulder. This is always a good visual device and very utilitarian. The artist also goes in for close-ups of, what else, the bomb! The first version didn't emphasize the most important component of the scene. If we're going to wait in suspense for something to blow up, we had better see the device ticking away.

LOCATION, LOCATION, LOCATION

Comic book scene locations are more than just backgrounds. They're strategically chosen environments that help to flesh out the story. The locales should also be interesting and evocative. For example, say that you have a scene in which a villain is talking to one of his investors about taking over the world. You could draw the scene with the two of them walking down the sidewalk, chatting. That works, but it's boring. On the other hand, you could stage the scene in the villain's vast garage, filled with his personal collection of Ferraris and Lamborghinis. Now *that* says something about the bad guy's wealth and self-indulgence.

Other locales are more a function of the story line but no less important strategically. For example, you could have a thief stealing from a person's home at night. But it would be so much more stylish—and elevate the thief—if he (or she) could pull off a robbery at a high-end jewelry store instead. Or you could put the thief in a museum to elevate the theft a notch more. And perhaps, the thief's stealing a rare antiquity.

The best locations are specific and register with the reader at a glance. This section will show you some of the classic and ever-popular locations for your super crime-fighters.

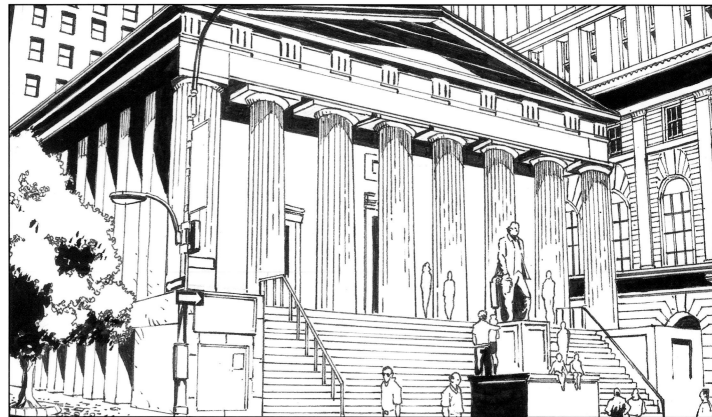

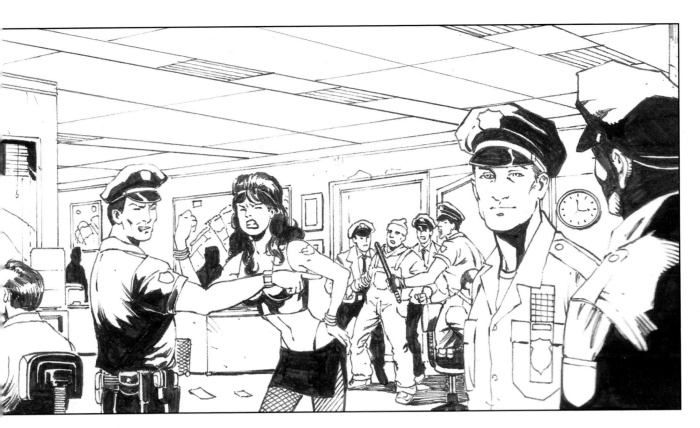

Police Precinct

The superhero has a love/hate relationship with the police. The cops are glad to get the criminals off the street, but they also don't like vigilantes. So there's usually interaction—and maybe a little friction—with the police department. The cop-on-the-beat character tends to be more supportive than those in the upper echelons of the department, who are more political and worried about covering their butts.

City Hall

Most superheroes live (and work) in a major metropolitan area. And the seriousness of the crimes goes all the way up the chain of command and gets the mayor's attention. City Hall features prosecutors, defense lawyers, judges, criminals, television news reporters, and even the mayor—a host of great characters for crime-fighting adventures. The mayor may make speeches praising, or condemning, the hero on the steps of City Hall. The downtown, city hall setting has to look majestic—it's where justice is served. Note the thick columns and steep steps.

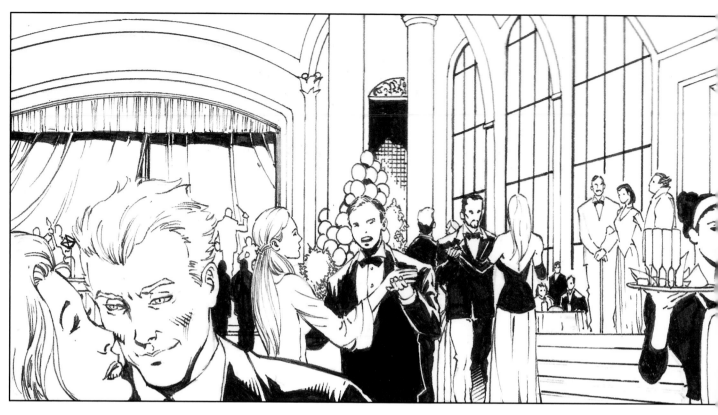

Prison Visiting Room

The prison visitation center is where the prisoner meets with his lawyer, separated by a bulletproof Plexiglas partition. Bad guys often have "mobbed-up" lawyers. Some of these nefarious inmates direct their gang activity from behind bars. Others get released through their tricky attorney's technical wizardry, overturning a jury verdict. Then, the prisoner is free to take revenge on the person who sent him away—the superhero. Note the "pressure marks" the partition makes on the prisoner's forearm.

Ballroom

Many superheroes are wealthy individuals who host philanthropic parties. Being a patron of the arts provides a great cover for their true identities. Opulent locales provide a rare glimpse into the lives of the rich and famous. At these events, plotting and scheming goes on behind the scenes between such types as diplomats and captains of industry. Opulent settings also give you a chance to show off your characters in stunning outfits. Supertall, floor-to-ceiling windows and arched doorways give the room an airy elegance.

Villain's Headquarters

It's a convention of supervillains: An underground network of powerful criminal masterminds meets as a great council to divvy up the world's resources. Scenes like this are important to make the bad guys part of an elite organization, functioning with one purpose: to get rid of the pesky superhero and, as a result, rule the world. In this setup, the icon for the world appears on the floor, surrounded by a seated council. On the screen before them is the organization's wicked mascot: the dragon. The two-tiered building allows the scene to be viewed from a high vantage point, as though we're looking down at it.